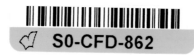

OUTSIDE THE LINES

Alexandra Nechita

WITH COMMENTS BY THE ARTIST
EDITED BY SUZANNE COMER BELL

LONGSTREET PRESS, INC.
ATLANTA, GEORGIA

Published by
LONGSTREET PRESS, INC.,
a subsidiary of Cox Newspapers,
a subsidiary of Cox Enterprises, Inc.
2140 Newmarket Parkway
Suite 122
Marietta, Georgia 30067

Printed in the United States of America

3rd printing, 1997

Library of Congress Catalog Card Number: 95-82242
ISBN: 1-56352-454-6
This book was printed by Horowitz/Rae Book Manufacturers, Inc., Fairfield, New Jersey.

The type was set in Giovanni and Kuenstler Script.

Book design by Leslie Cohen, Rhino Graphics
Jacket design by Jeff Cohen, Rhino Graphics
Cover photograph by David Butow, courtesy SABA Press Photos, Inc.

Alexandra Nechita is represented by International Art Publishers, 655 Anton Blvd., Suite A, Costa Mesa, CA 92626 (888-ALEX-ART). Or write to the artist at: Alexandra Nechita Enterprises, P.O. Box 9129, Whittier, CA 90608.

FOREWORD

NTO HOW many young hands would you have to put a paintbrush before you found an Alexandra Nechita? Hundreds of thousands? Millions? And if you did go door to door, with a bristle-tipped stick instead of Prince Charming's glass slipper, how could you be sure that the effort would be rewarded in your particular century? For it does not always happen that there *is* such a one, even among millions.

All kids paint, joyfully and with abandon. And we parents and grandparents and godparents applaud the results, which we post with magnets on our refrigerator doors. Let's be honest, though: If the family cat fell off the bureau into a pigment-filled pan and then skidded across a sheet of newsprint, the "painting" left behind would closely resemble those our little ones bring beaming back from school.

That is not what we are talking about here.

Alexandra Nechita is a child painter the way little Wolfie Mozart was a child composer—stunning because congenitally she possesses skills and depths that a long lifetime could only hope to develop. Imagine a newborn speaking the equivalent of Shakespearean blank verse. Imagine a toddler building the Parthenon with Lego blocks, or a kid too young to cross the street by herself appearing from her basement workshop with a gizmo that turns water into electricity.

At this writing, Alexandra is ten, but for years she has painted with a power and subtlety and certainty of touch that would make an old master blink. And she knows what she is doing: Her paintings are *about* something. All that brilliantly controlled color and exuberant form and energetic line serve a purpose, as real art always must.

We use the word *gift* so often nowadays that we have grown deaf to what it actually means. You are about to see in the pages that follow what it actually means: An ability almost impossible to believe and entirely impossible to explain, come down out of the blue like an invisible cloak, to transform the being on whom it settles.

One last thing. I am no historian or scholar of aesthetics. I leave the comparisons to others. But, looking at Alexandra's painting, I have noticed this: There seems about them all to be a kind of yearning, an upward-tending— almost as if her gift meant to point the way back toward the place from which it came.

CHARLES OSGOOD
CBS NEWS

ALEXANDRA
BEHIND THE LINES

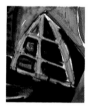

T BREAKFAST on a Saturday morning in December, Alexandra Nechita points up to the Christmas decorations that her fifth-grade class made to hang in Millie's Country Kitchen. "There's mine!" she suddenly exclaims, and strains to show her mother a construction-paper Christmas tree that looks like any ordinary grade-schooler's art. Viorica Nechita frequently strokes her daughter, this morning just a little girl who's wiggly and restless as she waits for maple syrup to sweeten her pancakes. Her grandmother will have to braid her hair for the gallery opening tonight, Viorica reminds the child—she looks much too old with long, honey-colored hair flowing down her back. Even just out of bed, with a sweatshirt thrown on and hair tucked behind her ears, Romanian-born Alexandra is naturally, stunningly beautiful. Yet it's hard to believe she's the artistic prodigy who at age ten became one of the hottest-selling artists in America.

In the spring of 1995, art collectors and the media began hearing of an unusual, new child artist who paints in the abstract cubist style of Pablo Picasso and in the vibrant colors of Henri Matisse. That September, Alexandra was featured on "CBS Sunday Morning" hosted by Charles Osgood, and since then the number of calls from interested buyers and media—and the price of her paintings—have blown over the top of her eight-foot canvases. CNN has featured her several times, leading a string of syndicated news and talk shows that have displayed her astonishing paintings. In December 1995, with the opening of her eleventh exhibit, at the Perry Gallery in New York, international publicity began flooding in—first with articles in the *London Daily Telegraph* and *Sunday Times*, then invitations for a European tour and television interviews around the globe.

Now that her age has reached two figures, the artist's earnings are about to hit seven. Alexandra has sold almost every available piece in a collection of 300 paintings—each one going for $15,000–$40,000—and is on the verge of breaking into the million-dollar level, an achievement that usually takes years for an artist to reach. The painting *Release the Peace* (p. 55) sold at her first show in 1994 for $700; two months later a couple tried to purchase it for $25,000. One recent potential buyer offered $150,000 for two paintings, representations of Snow White and the Lion King (pp. 5, 31), but the artist turned him down.

Mesmerized by the images Alexandra brings to life on canvas, many buyers also seek out a particular piece because of the simple, charming narrative behind it. About a painting of her baby brother, Maximillian (p. 21), Alexandra says: "When he's frightened he screams real loud. He's shedding tears and the fish come to live in the tears. The sweet flowers are on my brother's head because he's the honey bird." Flowers are a common motif, such as those in *Sunflower Fields* (p. 51) that weep over their "baby" sunflower left alone in the field. And many paintings, such as *Angels Don't Have Colors* (p. 29), express the immigrant child's yearning for worldwide peace and racial harmony. These stories explode on canvas in a richness of color and range of emotions; the fragmented, collagelike figures echo similar instincts behind European cubist and fauvist masters from earlier in the century.

———⊚———

Born in Romania on August 27, 1985, Alexandra came to the United States when she was one and a half years old. Her father, Niki Nechita, 40, fled their Communist homeland in 1985, when his wife, Viorica, 33, was six months pregnant. "It was a very stressful period," Viorica remembers. "Imagine a pregnant woman, a couple waiting to have their first baby, being faced with possibly the last chance to escape the Communist country." The tension was so great during that period that she was hospitalized for four weeks and gave birth to Alexandra a month premature. Facing tremendous political pressure, as Niki, like all escapees, was considered a traitor to Romania, the young mother and child followed him to Los Angeles, California, in 1987.

Even at age two, Alexandra was absorbed with her coloring books; friends and dolls seemed incidental. "She would color and color and color—intensely by age four," Viorica says. Her mother grew worried and actually stopped buying her coloring books, hoping she'd jump rope and play with her dolls and friends more. "So we didn't buy her any more coloring books. It was really hard, but we just wanted to see. It was like we took the oxygen out of her. What she did, she started to draw—I saw her—I used to bring home two inches of scrap computer paper a month, and she started to draw her own figures and color them. They weren't sophisticated, but you could clearly see she was inclined toward this Picasso-ish four eyes, two faces, a profile with hair coming from a different side. I was relieved in a way. My husband and I said, 'There's nothing wrong with her. She just loves it. We shouldn't punish her.' She made her own coloring books, and that really taught us something; she answered us this way."

Niki then bought her watercolors and another waterbased paint called gouache. The change was awkward for Alexandra—a preschooler, after all, who was still learning to color within the lines—but when they introduced her to oil paints at age six she simply couldn't let them go. Soon she asked for larger canvases on which to express herself. "We had to struggle to buy her art supplies because they were very expensive," Viorica says, and they worried when she would paint more than one canvas a day. They tracked down materials at close-out sales, and Niki stretched and treated the canvases and built frames. Even today, Alexandra mixes paint in baby-food jars.

Before age eight, Alexandra surprised her third-grade teacher with an apartment full of abstract paintings reminiscent of Picasso's cubist phase. "He came and took so many pictures," Viorica says. "He was speechless." At school she never talked about her painting; she was frustrated when she couldn't draw regular figures like her friends, and they teased her about the weird characters with funny eyes and multiple faces that she sketched during recess and breaks. But her first art exhibit on April 1, 1994—some sixty paintings shown at a community library—drew more classes of curious students than the library staff could remember ever having. Coincidentally, a Picasso exhibit had recently opened at the Los Angeles County Museum of Art, and Alexandra asked her parents to take her—to see the great artist's work for the first time.

Alexandra had sprawled out all over the town house by then—paintings in the upstairs bedroom, the living room—and the neighbors and property manager began to wonder about the frames and canvases spilling out around the door. "We had French windows and everybody looked at Alexandra when she was painting," Viorica recalls, "and I said, 'This is no life, I have no privacy.'" Now in a small house in Norwalk, California, Alexandra paints in a larger area designated as her studio.

In the summer after her third-grade year, Alexandra began taking her first formal art classes. Elmira Adamian, her drawing teacher at the Barnsdall Junior Art Center in Hollywood, was speechless, she says, when she saw the youngster's sketchbook that winter and took it to show other artists and teachers. Recognizing her distinctive style, Adamian encouraged the Nechitas away from giving Alexandra formal training, but instead urged them to let her develop naturally and innocently. They finally agreed with the teacher after briefly enrolling her in an area school that taught a strictly academic style of drawing.

As Alexandra was assigned to draw a model horse part by part, her parents read an article about the school's methods: children draw and paint for a session, then during breaks the teachers show them pictures of Picasso paintings to make them relax and laugh. Her parents say they shuddered at the mixed message Alexandra would receive; meanwhile Alexandra had (of course) drawn a horse with several eyes and teeth on the side of its head. Her teacher reacted immediately, turned her paper over, and asked her to start again. ("The teacher said horses don't have such bizarre teeth," Alexandra recalls.) The Nechitas never went back, and since then Alexandra has relied on her own intuition, family support, and private encounters with the works of great artists in exhibits and art albums.

Ideas for her paintings come from everyday life, but a trip back to Romania in June 1994 was like a flush fieldwork excursion. Alexandra came alive amidst the mountains and village market, her grandparents' farm and country cottage, the stream-drawn water and unexpected outhouse. The Nechitas celebrated Christmas in June with the ritualistic sacrifice of the family pig (Viorica didn't let Alexandra watch, since she had befriended the pig), traditional foods, and wine from her grandfather's own vineyard. Expressing a passion to preserve her native culture, Alexandra has painted about ten paintings based on her only trip back to Romania. One of her favorites, *Summer in Europe* (p. 3), garnered a $50,000 offer, but Alexandra wouldn't part with this special tribute to her grandfather. "He used to hold me on his warm lap and tell me stories of his very young age," Alexandra says. "My grandfather was a very handsome guy—he still is."

During the fourth grade, at age nine, Alexandra had several more exhibitions in the Los Angeles area—building up her collection to more than 250 paintings. A CBS producer noticed her work at the Mary Paxon Gallery in the spring of 1995, and an artist's representative spotted paintings in a local bookstore in July. By late summer, Alexandra was awaiting her appearance on "CBS Sunday Morning" and had just become the youngest artist with International Art Publishers, based in Costa Mesa, California. Collectors and the national press couldn't get enough of the "pint-sized Picasso," "the Mozart with a paintbrush"—a child whose bizarre talent, uncommon beauty, and charismatic personality were almost too good to be true.

Painting in her "magical shoes" (a pair of well-worn slippers) and wrapped in a paint-splotched apron, Alexandra gains momentum from Vivaldi's *Four Seasons* and other choices from her classical music collection. With poised, fluid

motions, the artist gestures dramatically as she paints or talks about her work, and often leaps up onto her stool to reach the upper half of a canvas. She has no sophisticated comments about her cubism, she just does it: *"Forgotten Values* [p. 9] is a very, very good example of how I paint in a cubist way. I just started off with some shapes of a head— some triangles and rectangles. I didn't even have to think about the similarities of the realism and the surrealism. I never sketch realistically; that makes it so much harder. I can't express myself and don't show my freedom. It's not my natural way."

Alexandra is just as pragmatic about her extraordinary gift for painting. Other kids in her class are very talented, she says, and mentions a friend who draws cartoons. But what separates her, she believes, is her steady, hard work to develop her skills. "I'm just a normal child. I go to school, I come back, I start painting. Some just go outside, some skateboard, go play tennis, play ping pong, or whatever they want to do. But this is what I choose to do." Every afternoon, she does her homework and chores, eats a late-afternoon meal, and plays with baby brother Maximillian. Then she retreats to her studio and paints for several hours in the evening. On the weekends she carves out even longer sessions. With a rare sense of purpose and strong concentration, Alexandra completes large paintings weekly, sometimes several in a week.

———◉———

Tonight Alexandra will open her twelfth exhibit, displaying a fresh group of new paintings at the International Art Gallery in Costa Mesa. During the drive south, Alexandra is held tight under her mother's wing, fighting a cold and carsickness due to the jarring, busy interstates. She dashes past security and into the bathroom when they arrive, to gather herself and change out of her shorts. Already the gallery is buzzing with art collectors and the otherwise curious, including a collector from Belgium who will spread word to the queen, parents with their children, and recognizable faces from Hollywood.

At last Alexandra appears in a sporty miniskirt and plaid vest, petite among her urbane guests in black attire and sleek hair. Everyone wants to meet this darling prodigy, to hear firsthand how she was inspired to paint each piece. Alexandra is naturally both poised and playful—most excited that she can show her paintings to a new entourage of admirers. The sales, in her child's mind, simply mean she can buy more art supplies and keep developing her talent.

(Still, she doesn't flinch when she responds to a compliment: "Yes, that is a very good painting." Or, when asked to pick her favorite: "I love all my paintings; they are all a part of me.")

Soon Alexandra mounts the platform where the Romanian consul, Mihai Sion, has introduced her to the 300–400 guests. Viorica suddenly finds herself midway back in the crowd and can't even see her daughter. "Oh, is she speaking already?" she asks, distressed that her little girl is alone without her. But Alexandra is completely composed as she welcomes her fans and leads them across the gallery to unveil two Disney interpretations. Pointing up to dazzling 6 1/2-foot canvases, she names each dwarf around Snow White, then identifies the Lion King and his friends.

By 10:00, after being the center of attention for five hours, with two security guards keeping up with her quick darts from room to room, Alexandra settles quietly into the back seat of the car. "Yes, I had a great time and met some very important people," she says, but then is most interested in what decent restaurants are still open. Soon she slides into a booth at the Olive Garden and eagerly receives a child's menu and crayons. The adults discuss sales and contacts made, plans for an imminent European tour, but Alexandra takes the coloring book and tries out her green crayon.

Like a cool-down exercise, coloring completely absorbs Alexandra, and she delights in staying cleanly within the lines of the cartoon figures. Little does she seem concerned with the boundaries she's been crossing in prestigious art galleries for the past two years and the last five hours. She misses Maximillian, who stayed home with her grandmother, and she's ready again for the magic of her slippers and the paint-stained apron.

S.C.B.

OUTSIDE THE LINES

Alexandra Nechita

Summer in Europe

60" x 80", acrylic on canvas, 1995

I was born in Romania and in 1994 I returned there with my family to visit. This painting brings back the most wonderful memories of visiting my grandparents. My grandpa has a winery in Romania, and he and my grandmother live on a farm during the summer. One day my grandpa and I were playing the accordion and he decided to give me a few sips of wine, red wine he'd made with his own hands. You can see the accordion is on the left, and my grandpa is green, on the right. I'm sitting on his lap. The shadow's lips are attached to the glass of wine. The shadow belongs to both me and my grandfather, showing how anxious I was to get a sip of that wine and how proud he was to share it with me. On top there is the base of the Eiffel Tower, which symbolized my grandpa's and my dream to go see it. Every time I would help my grandpa…I just remember his face, wrinkled with puffy cheeks and red nose. I had so much fun.

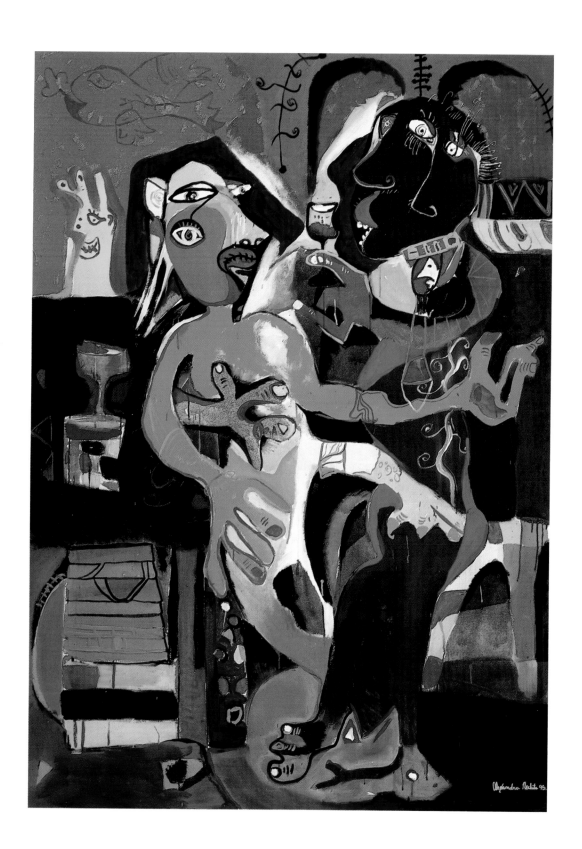

Variation on Snow White and the Seven Dwarfs

70" x 80", oil and acrylic on canvas, 1995

All children love fairy tales and fall in love with them, and even though I am older I like people to know that I still fall in love with fairy tales, too. I still love Cinderella, Dopey, and all the characters. In this painting the prince is half of Snow White, since he became part of her life and they lived happily ever after in the castle. Below Snow White's dress are the dwarfs (left to right): Sneezy, Grumpy, Doc, Bashful, Dopey, Happy, and Sleepy. I painted the magnificent castle and the poison apple, but I didn't want to paint the queen.

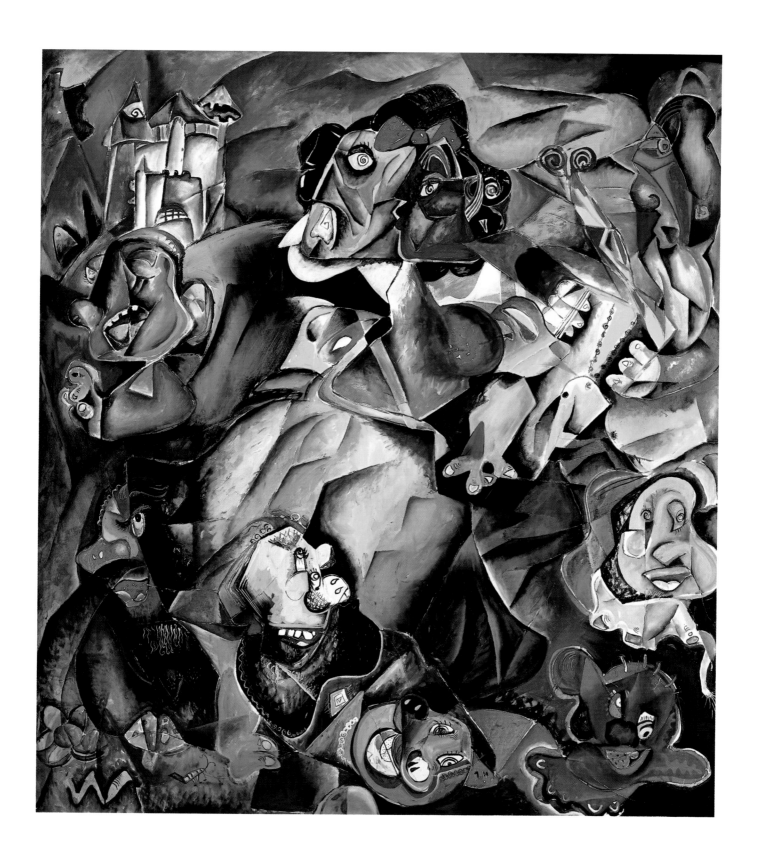

Chicken Escape

36" x 72", acrylic on canvas, 1995

When I visited my grandparents in Romania, I would always go and feed the chickens corn and flour with water. Every time they would peck on my fingers when I would walk by and my hands would be hanging down. One day I left the gate open and they all escaped. They were running everywhere. I was stepping on the garden flowers, throwing them back in the pen. When we would go to the city, where my grandma and grandpa have another residence, they would take three, four chickens in the car. We would have to sacrifice them when we got to the city, to make barbecue, soup, or other Romanian dishes.

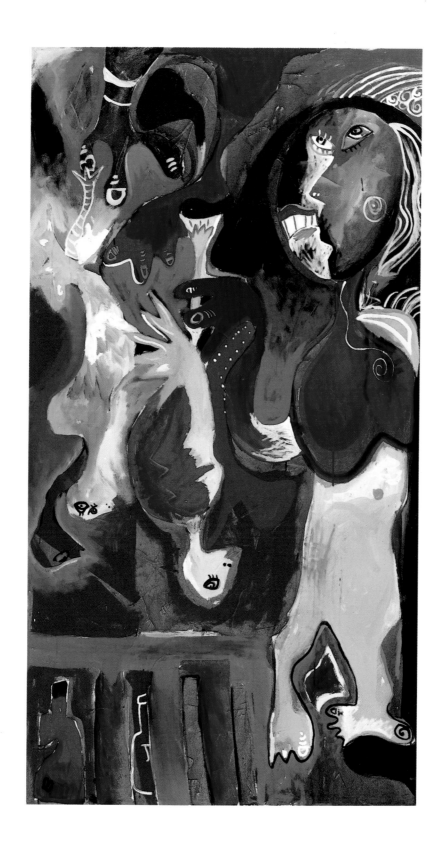

Forgotten Values

36" x 60", acrylic on canvas, 1995

This painting portrays people who are blinded by their fame and fortune and forget about their families. Many people who become famous promise to their families that they will always be with them. Then they think they're big, and they forget their families. They realize along in the years that nothing in the world has greater importance to them than their families. In the painting you can see a very clear shape, a hollowness inside the figure. He wants to go back to his family and his family will not accept him because of what he has done. Living without a family is like being a tree without leaves.

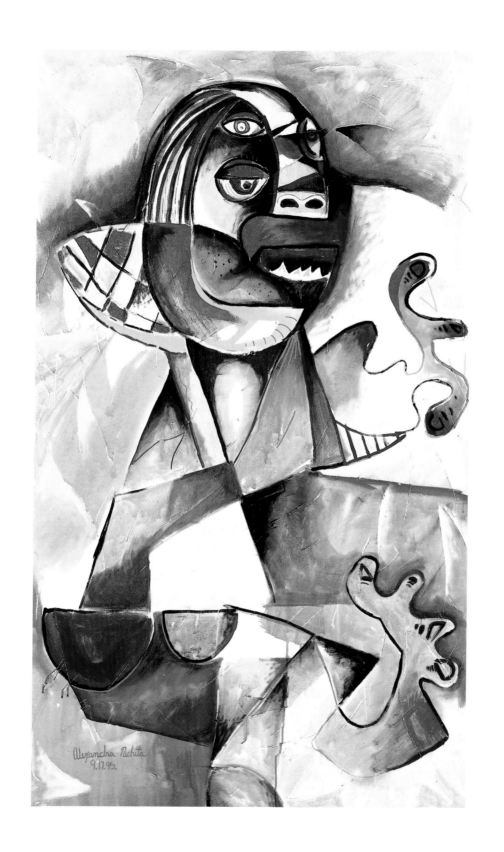

My Superman

60" x 60", acrylic on canvas, 1995

My dad is my superman because without him going through his troubles—when he left Romania and came to the United States—without him I wouldn't be in America. At that point, in 1985, it was really tough to escape. My dad really made our dreams come true. He is my hero because of what he's done, his courage. He could have been jailed trying to escape the country. It was totally illegal. He risked his life for my mom and me, so we could be in a safe place, somewhere where we could have the freedom to make our own choices.

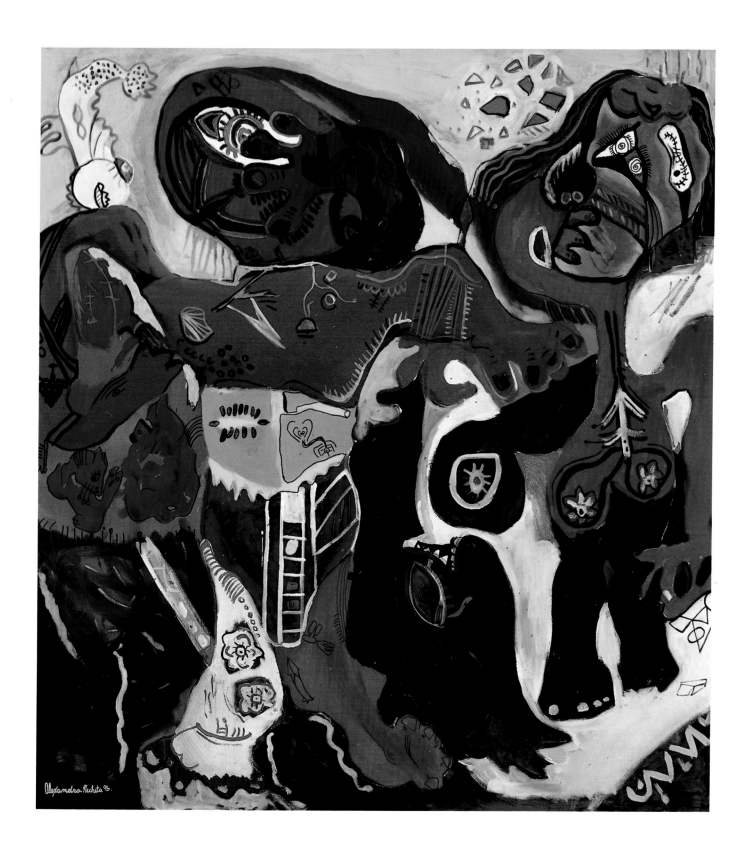

Captain Nechita

60" x 72", acrylic on canvas, 1995

This painting is about my dad's dream of going fishing on a big boat in the ocean. In his early experiences he told me that he would get very, very seasick from going out on a big boat. My dad has also told me every day, if I have a dream to make my dream come true, to be persevering, to never let my fears hold me back. I have followed in my dad's footsteps. It's come from both my parents. I am just telling my dad in this painting, "Now it's my turn to tell you the same thing. You have to be persevering. You can't let your fears hold you back." In this painting I caught the big, big fish. I'm here on the right, Captain Nechita, and this is my father on the left. The blue sun is shining on my dad, all the light is shining on him. He wants to go fishing but still doesn't have that strong, strong courage to go in a big boat out on the ocean. I know he will one day.

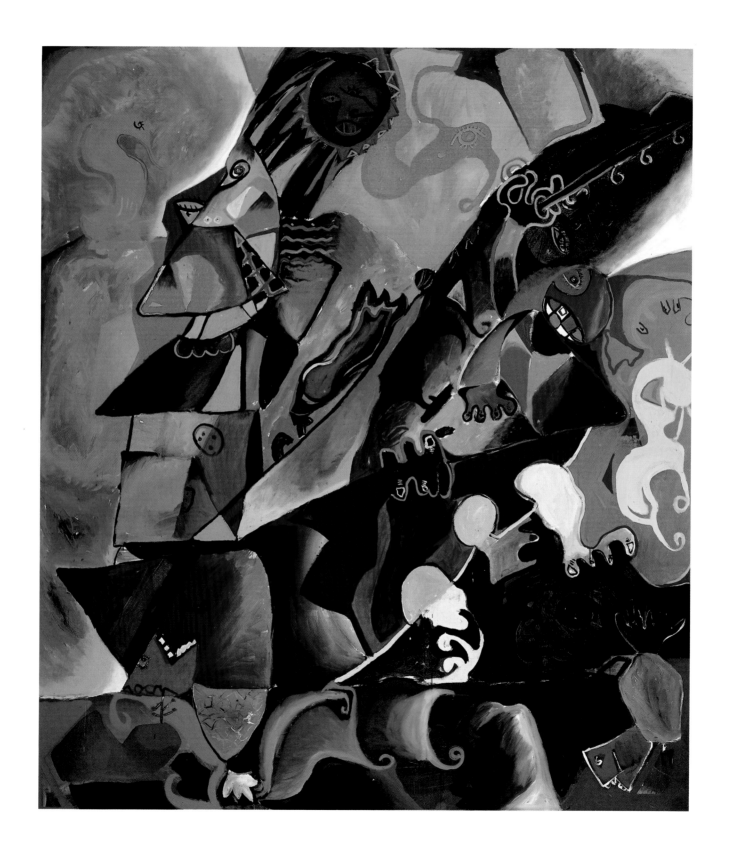

Heart Transplant

36" x 60", oil and acrylic on canvas, 1995

I am so touched by the courage, hope, and faith some people have in times of terrible illness. You know, I often think of people in need of a transplant of any organ, when they lie down on the surgical table, surrounded by blinding lights and metal noises. I wonder what they think of besides themselves, their loved ones, the happy, sad, good, or bad moments in their lives. Are they scared, or does the willingness to live take over the weak and sad feelings? This painting illustrates heart transplant surgery, the historical moment in some people's life, the experience of a new and welcome second chance. The new heart enters in this man or woman who is so anxious to receive it and regain his or her loss. Is it a loss when something in our body isn't working properly and it must be replaced, or should we think of it as a gain?

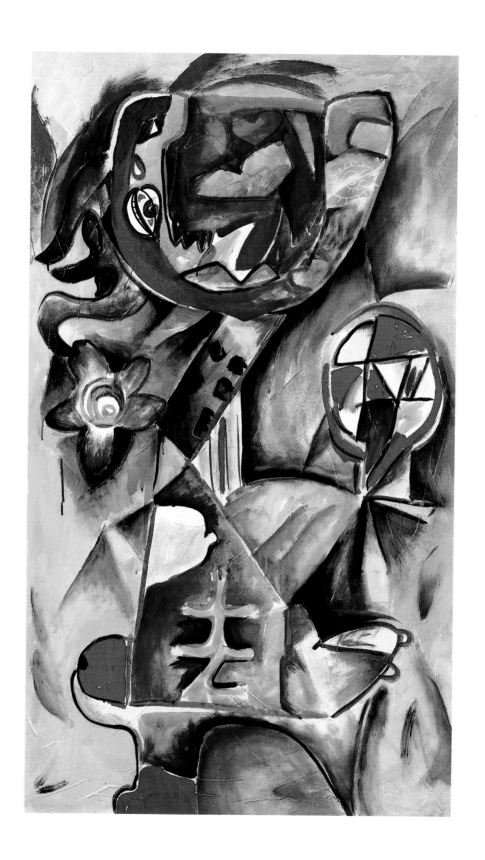

This is a yellow person and a black person, and the white person is behind them. They are holding a white dove, which symbolizes peace. The black hand couldn't be holding the dove without the white hand, and the white hand couldn't hold the dove by itself without the black hand. So they need all the nations holding the dove together so they can share peace together. The flamingo is standing for pride. Their body is the world, and peace is attached to the world. Two heads are emerging from one neck. The message—how happy and peaceful we could live with one another no matter what the color of our skin is—was easier to send that way.

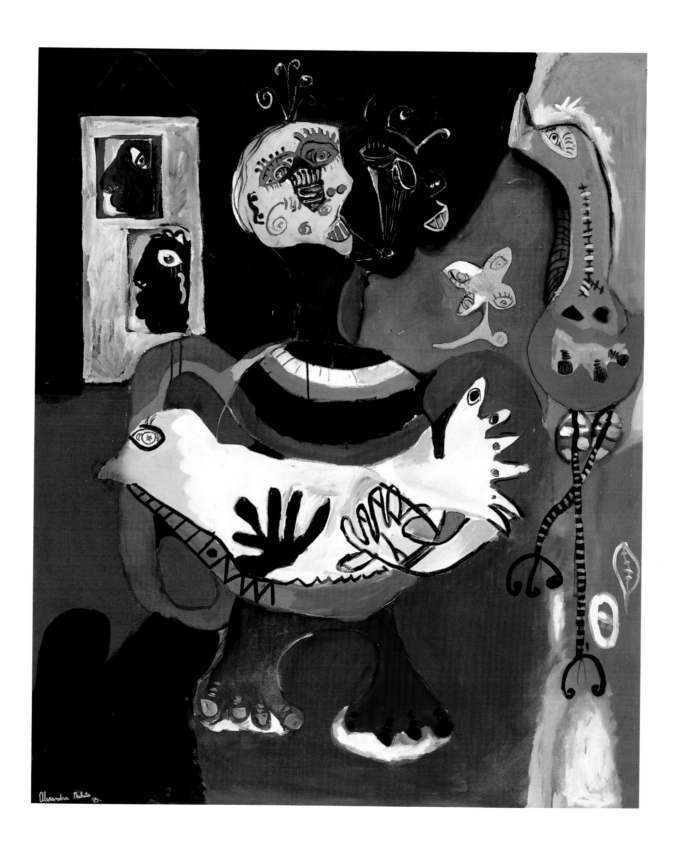

Peleș
[PEL´·ESH]

65" x 96", acrylic on canvas, 1995

While in Romania, I went to the mountains with my cousin Dana who lives in Romania and visited the castle where the king and queen of Romania used to live. This is the king holding the three colors of the Romanian flag—his fingers are red, yellow, and blue. And I always thought of the king playing the violin or some other instrument. He is holding a vase in his hand with olive branches for peace. The castle on the right is an angel to protect the king and queen. There is a lake right behind the castle with very beautiful swans. They now live in Switzerland.

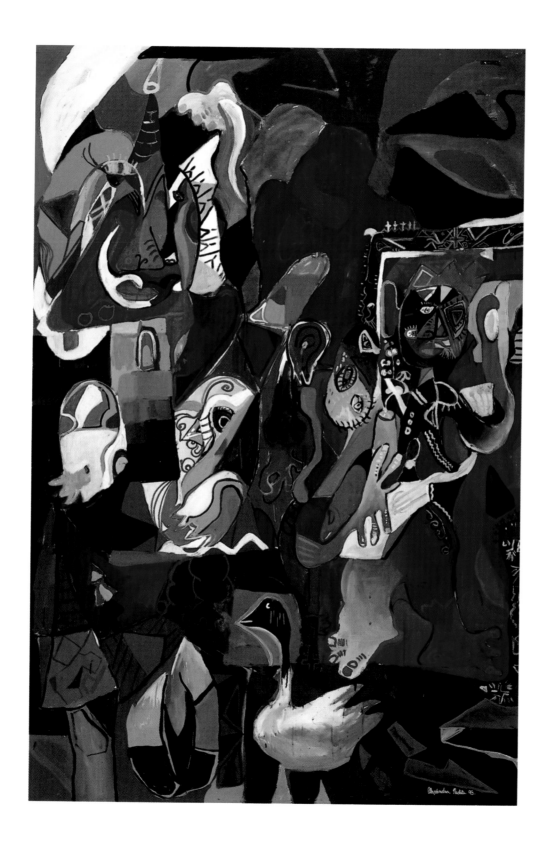

My little monster! This is Maximillian, my baby brother. I painted this when he was about three months old and I imagined him with teeth. When he's hungry, he's *hungry*. He will do anything to get his food. In his mouth is a fish. The fish is coming to live in his tears. When he's opening his mouth wide, the tears are going into his mouth. His crib is made out of bottles to show how hungry he is, his pacifier is in his hand, and in the upper left is a hummingbird. Surrounding his head are sweet flowers, and hummingbirds love flowers. They're showing how sweet my baby brother is. I love him very, very much.

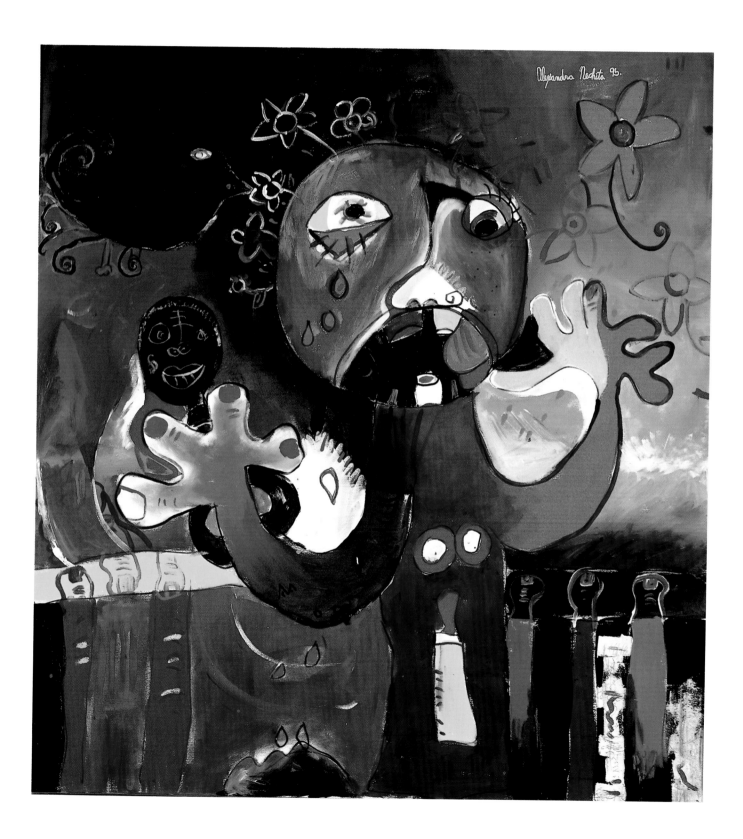

Sharing Moments

38" x 48", acrylic on canvas, 1995

Sharing Moments is about generous people and selfish people. The person on the right doesn't want to give. You can see her evil eye. And the person on the left wants to give. One hand is holding the bowl of apples back away and the other is giving it. Some people aren't as lucky as us to have food, to have homes, so we can't just be thinking of ourselves, especially when it comes to holidays. They may not even get a chance to see a Christmas tree or light their own candles. The green symbolizes bountiful nature and happiness. The blue is sort of dark, like the selfish person. Yet the blue is next to the giving person.

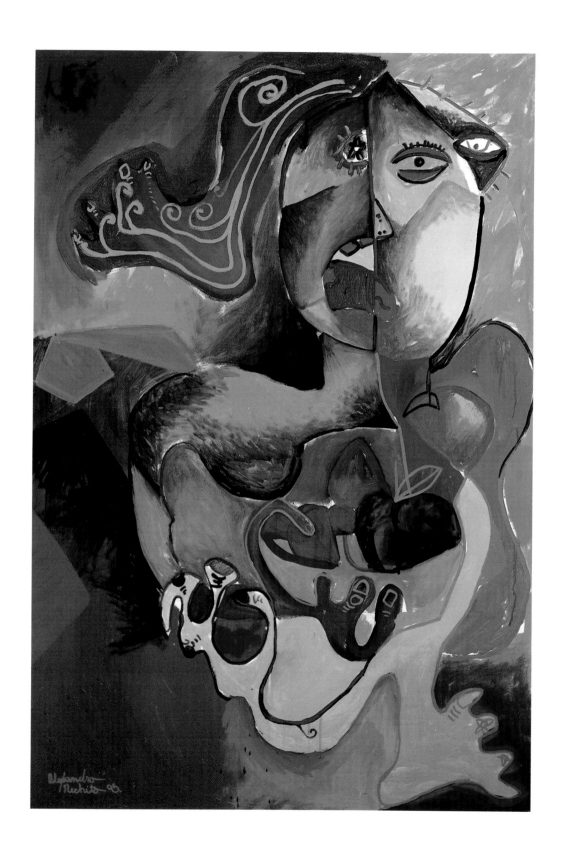

Breathless

36" x 60", oil and acrylic on canvas, 1995

I went with my friend Steve to Disneyland to see the Pocahontas play and he kept on wanting me to go on the roller coaster, the Matterhorn. I said, "No, I don't want to, I'm afraid of roller coasters," and just to tell you now, I'm not a fan of roller coasters. So I went on the roller coaster, and this is how I felt on it, especially when I got off. I was so breathless, I didn't have enough air to breathe. The sky and the earth were blended together and my world was moving in circles. My legs felt upside down and my eyes and ears were so, oh so hot. Thinking back, it was a lot of fun—but that doesn't mean I have changed my mind about roller coasters.

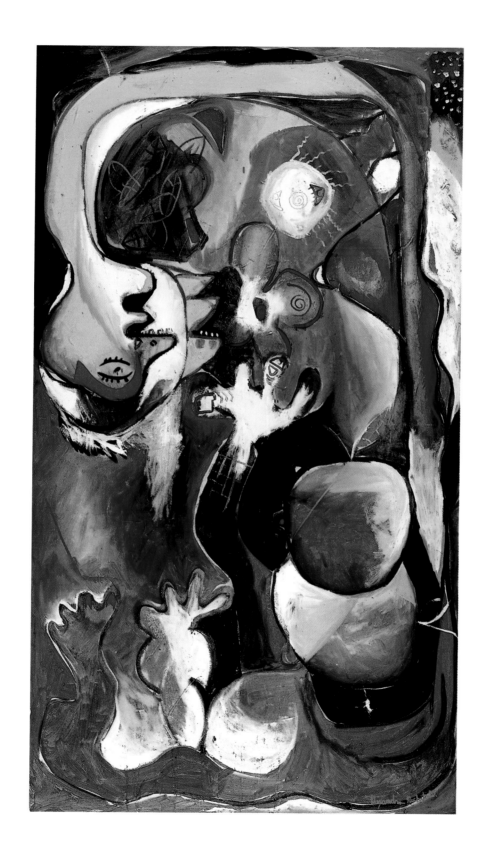

My Gardener

36" x 72", oil on canvas, 1995

I believe that a gardener not only can help the flowers maintain their life but also actually give them a life. A gardener is a very special person to flowers and to plants. You can see that the gardener gave a life to this red vase by putting the flowers in it. Can you see my fingerprints beside the gardener's face? They represent his own special touch. Gardeners are people with plenty of patience and inside beauty for their flowers' life.

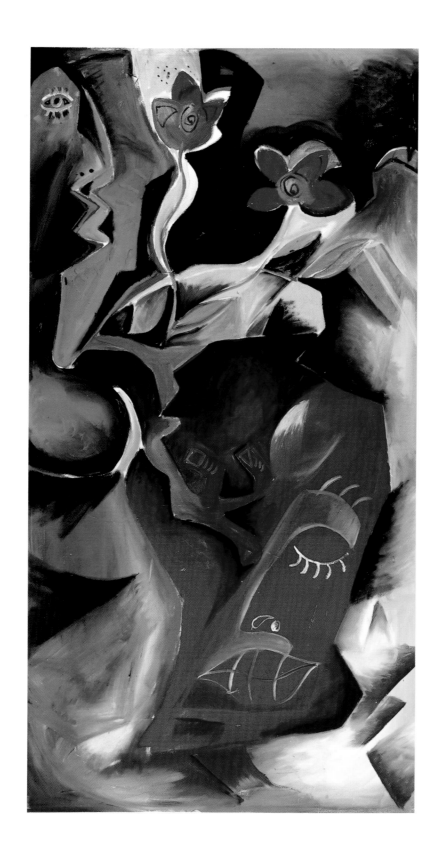

Angels Don't Have Colors

48" x 68", acrylic and oil on canvas, 1995

The message I am trying to send through *Angels Don't Have Colors* is that we, all of us, should not judge others by skin color. Rather, we should be more willing to live free of the racism that holds us prisoners. Three angels—black, yellow, and white—are together on the same canvas and are sending messages of peace (like the dove inside the yellow angel's heart), messages of being motivated to preserve our world for future generations. I believe we all have a meaning here on earth and that we should make efforts to think, love, and care for each other.

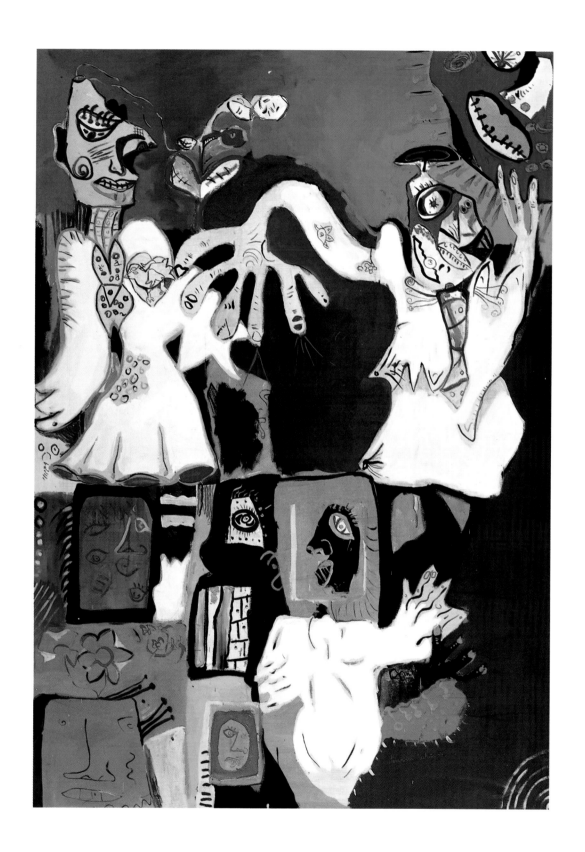

Variation on the Lion King

60" x 80", oil and acrylic on canvas, 1995

When the Lion King was little he was always afraid of the elephant's tusks. This scene in the movie was special to me because in the end the Lion King gains the courage he needs to show his strength. His father always told him never to go to the shady part—the elephant burial ground—because that was evil and scary, where the dead lived. He did not listen. Now he has become king and is proud; he is mature enough to understand good and bad and he is grateful to his father. The elephant tusks are in front of him, showing the power and courage he has; now he can go to the burial ground. Part of his face is Nala (the green eye), and Pumbaa and Rafiki (on either side) are his very good friends. When he was born a star was shining, and he promised he'll never forget where he was born, on the Pride Rock. And his star helped him to return as a king.

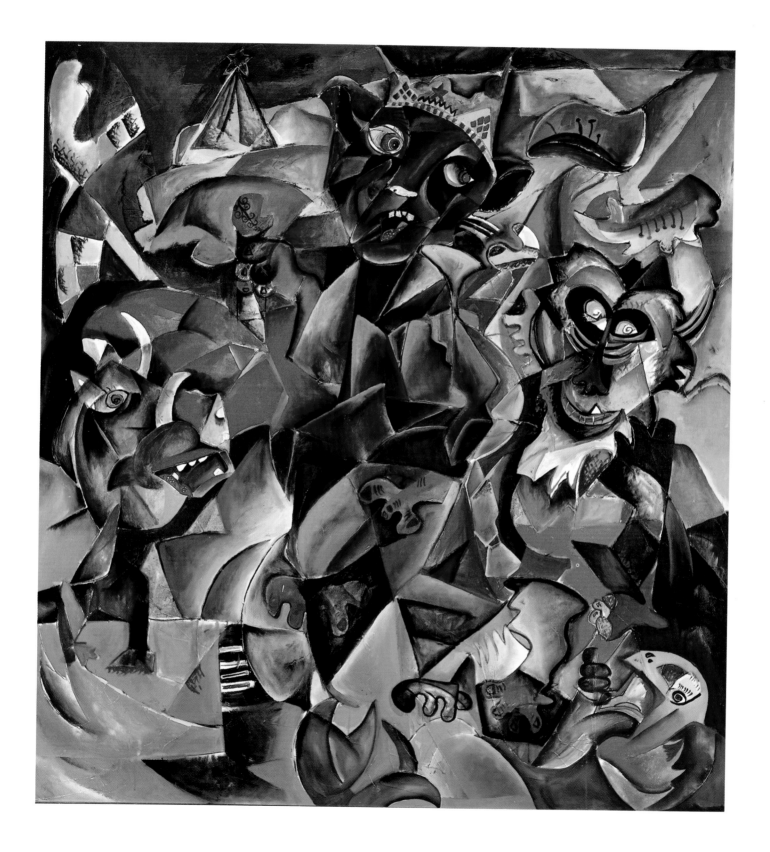

Eureka

18" x 24", gouache on paper, 1994

This lady represents our state, California. She's holding a dove in her hand, and the dovetail is part of her dress. She's saying, "Eureka! I found it!" She's saying she found the peace, and she wants to share it with everybody in the whole world. Eureka comes from the Gold Rush in California. California means peace to me because that's where my dad came when he left Romania, and my mom and I came when I was one and a half.

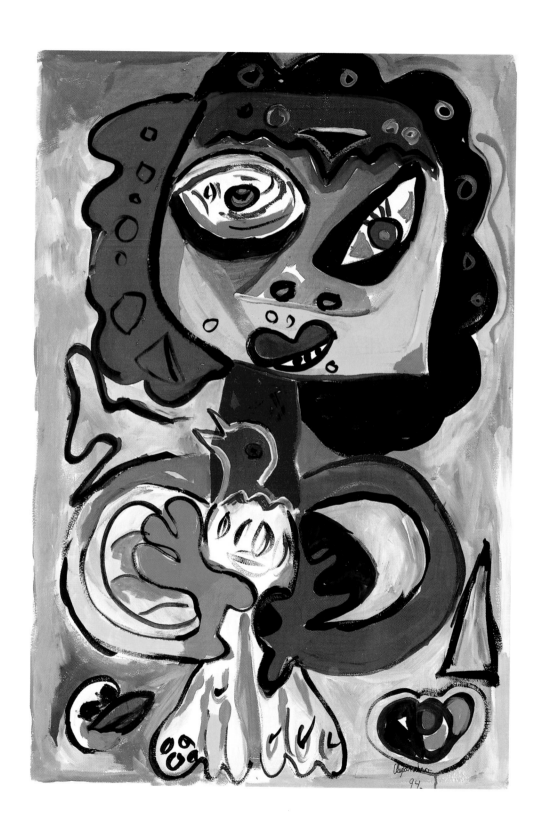

Mr. Evening

36" x 62", acrylic and oil on canvas, 1995

I went to the San Diego Zoo, and in this painting there is a giraffe, a bird, and a monkey. It was so terribly hot—you can see the red, which indicates the horrible heat. When it came toward evening, it was like someone was blowing the cool air—blue—toward us. The blue represents the cool and calm night. And it felt so good.

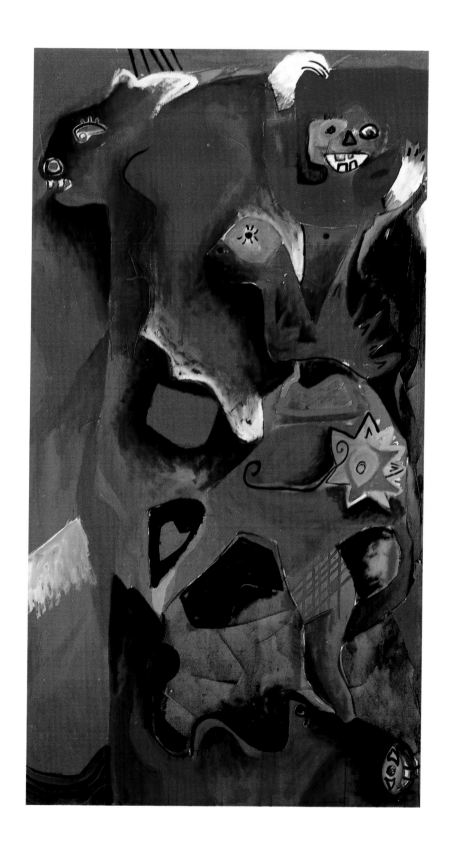

Little Wooden Horsey

36" x 60", acrylic on canvas, 1995

I used to be in love with a little wooden horsey in front of a store near my home, which I rode many times when I was four and five years old. It was my favorite rocking horse. I used to worry that the horsey would get cold or wet when it was raining or cold winds were blowing, but my parents told me that the people at the store would take good care of it. They were right—he was always warm and darling every time I touched him. Now the store is gone—when I heard it I was so disappointed—but when I ride by the place where it used to be, I always think of my little wooden horsey.

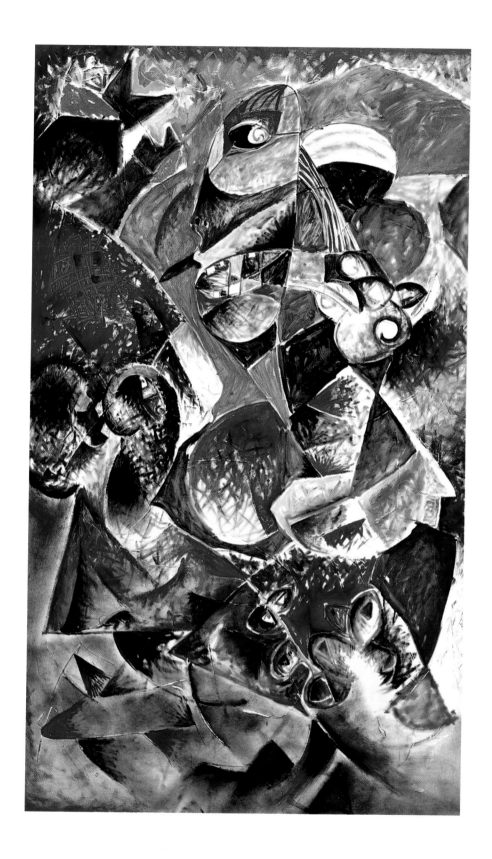

Electric Flowers

36" x 48", acrylic on canvas, 1995

Two friends are holding a flower that is electrocuting one of them.
The other person is trying to stop him from being electrocuted.
The blue shape is a building—it's sort of an earthquake thing. I
used flowers because I didn't want to have just buildings, the usual
earthquake images. The electric flowers are symbolic of what an
earthquake is like. I welcome you to use your imagination and give
your own interpretation. I like to know that people are looking at
my paintings and are trying to find the story behind them. It is dif-
ferent than just looking—they are thinking as well.

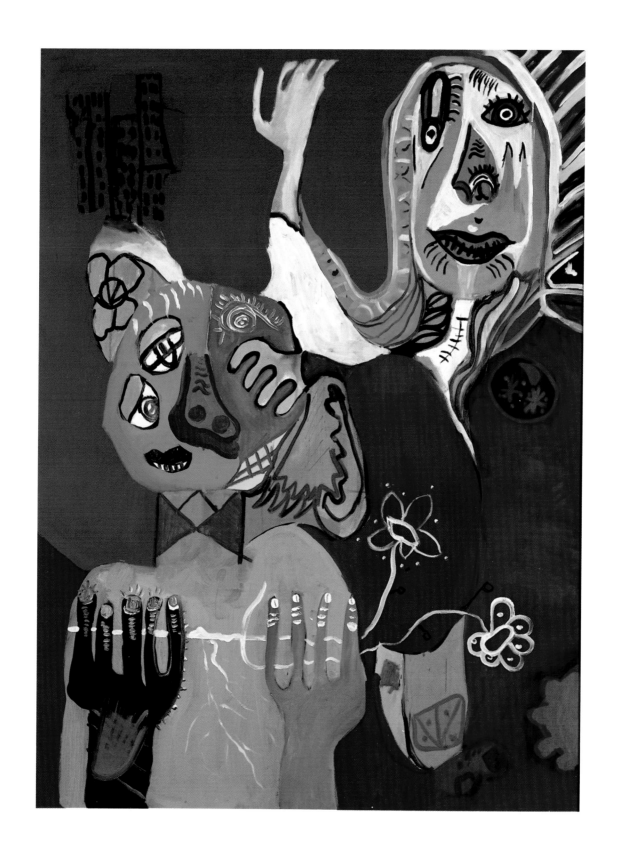

Birds

36" x 60", acrylic on canvas, 1995

When I went to Romania, we had quite a few birds—white, brown, and gold baby chickens. We would have to take them to the city from the farm and sacrifice them. I felt so sorry for them and also because every morning I would wake up and take their eggs at 6:00 A.M. I knew their eggs were their family, I felt very sorry, but then I thought again, "But no, if I leave them there, they are going to rot away and it would be worse." So I had no choice. At the same time, I would eat them and they would get in my tummy. It was very good to eat fresh, fresh eggs.

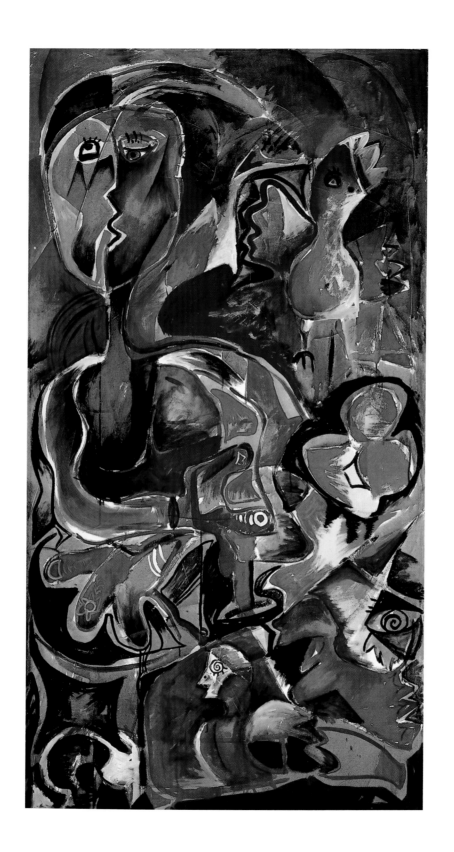

The Comedy Lover

36" x 60", acrylic on canvas, 1995

In the last three weeks of summer before I started school this year, I was very sick with scarlet fever. And I was sick with pneumonia, tonsillitis, and an ear infection all at the same time. I had a 104.9 degree fever. A friend of ours, Deborah, came and did a fomentation on my back. She used a cold ice rag, with another rag on top. Then she'd pound on my back very hard, and I had to cough and cough to get all the bacteria out. Then she would put a boiling rag on my back and do the same thing over. She told me the only way I was going to get happier and better inside was by watching comedy—Lucy, Benny Hill—no Lassie, no dying puppy stories, no Free Willy. In this painting I'm telling people that through bad times, they should always try to keep a smile on their face.

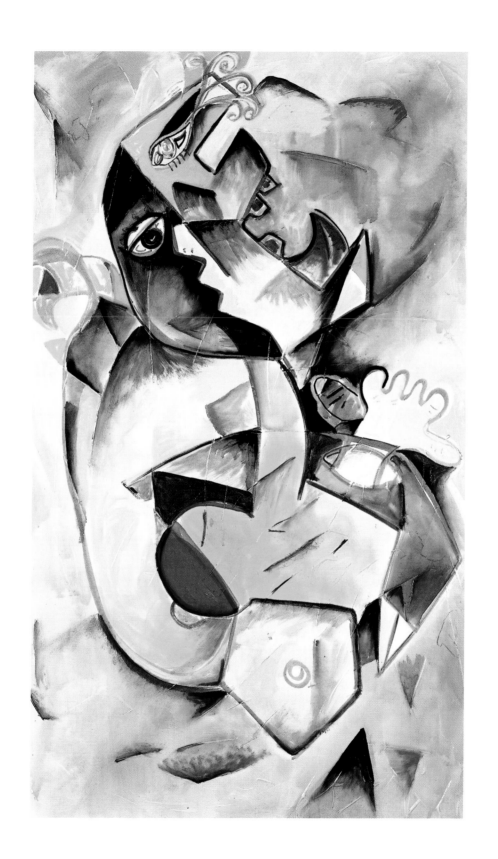

Soldiers Never Die

48" x 60", acrylic on canvas, 1995

This painting is a tribute to all the soldiers around the world who have lost their lives on the battlefields. It's about their incomparable courage to fight until the end—and their struggle to leave their families behind. This dead gray pigeon symbolizes all the lost lives of the soldiers, and the dove symbolizes the ones who have survived. You can see this man on his knees in honor of the soldiers' heroism. He has on a priest's robe. The white dove is bringing flowers in his beak to the bird that is no longer alive.

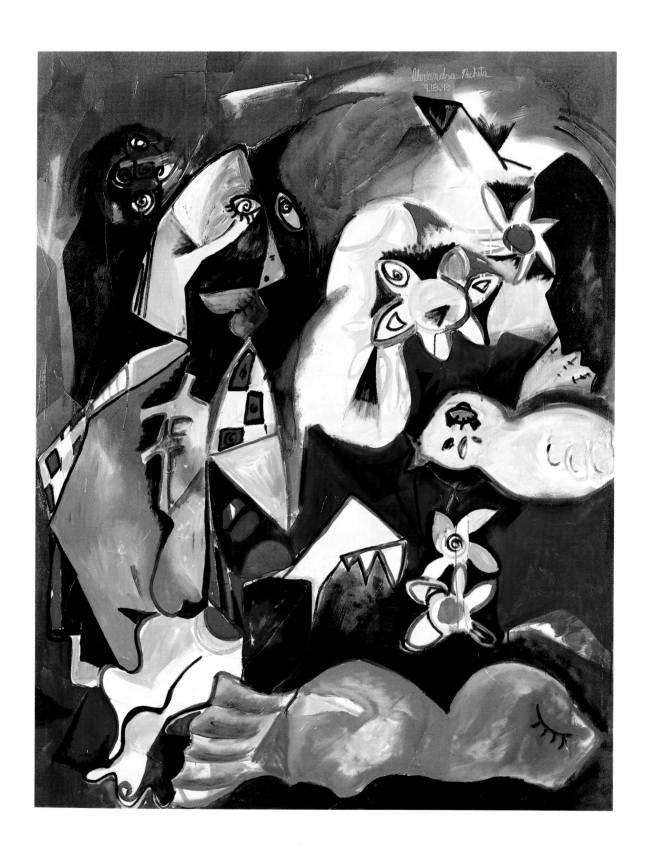

True Love

52" x 72", acrylic on canvas, 1995

This painting is about my mom and my grandmother's unconditional love toward my baby brother and me. It's about how nice they are to us—even ten thousand times more than nice. They love us so much, and my mom's so playful sometimes that I don't know how old she is. She seems like she's ten sometimes. Even though she comes home from work sort of grouchy—it's just that they're busy with grown-up things that we don't understand—I know that she loves us very much.

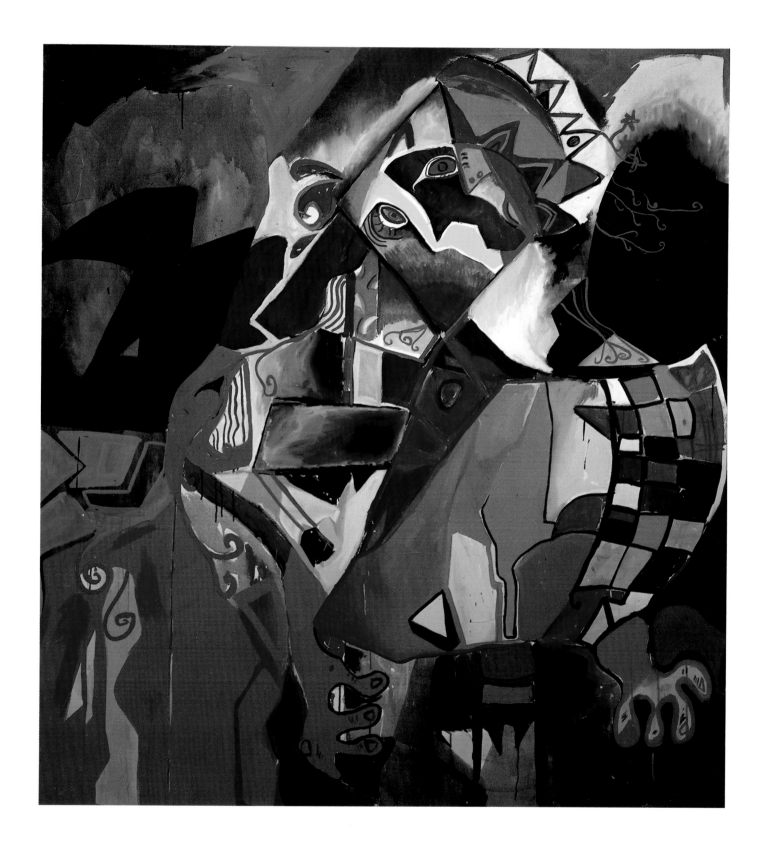

Vegetarian Thoughts

36" x 72", oil on canvas, 1995

These are two friends who are sharing their thoughts about eating habits. One is telling the other how much he enjoys eating meat, lobster, and junk food. The other is trying to convince him to become a vegetarian, because by eating meat you're ending an animal's life. The meat-eater is puzzled, and you can see by the shape of his head his willingness to make a change. The meat-eater is on the right, with the hollow part on top of his head. They are sharing the flower together. The green is a color of the garden and nature.

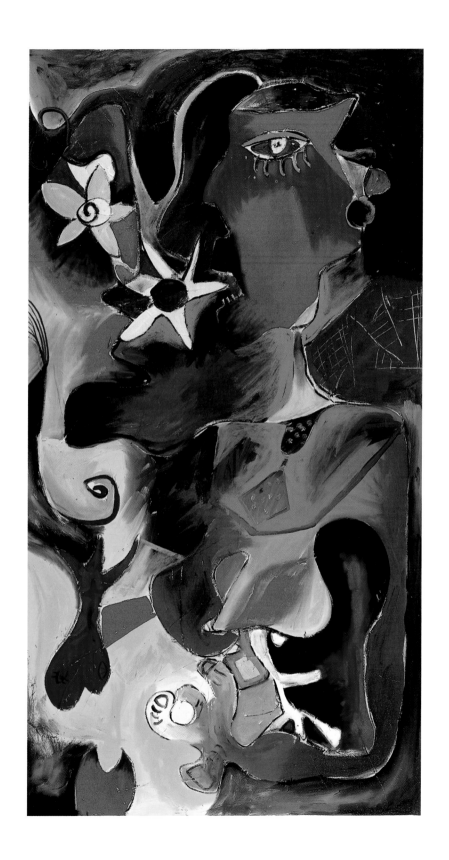

Sunflower Fields

36" x 72", acrylic on canvas, 1995

My parents and I were driving across these very beautiful sunflower fields one day. There was a gate surrounded by tall sunflowers and baby sunflowers, and on the gate a sign said "No Trespassing." Some people were picking the sunflowers, and they were picking them so fast that it seemed like they wanted to steal. I saw that they picked two big sunflowers and left a baby one behind. This is the father and the mother; you can see the agony they went through because they had lost their baby sunflower.

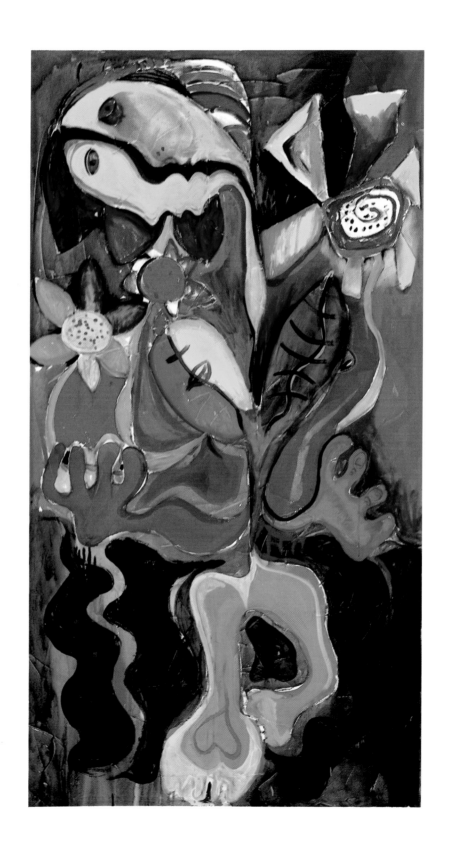

Maternity

36" x 72", acrylic and oil on canvas, 1995

Maternity is about all mothers and their children and the happiness they share. And also the pain they share when they are in labor. I remember when my mom was screaming and I heard her all the way down on another floor at the hospital, then how happy she was when Maximillian was born. Sometimes a mom is tired and lets the baby cry a little bit, then runs back to him. It doesn't mean she doesn't love him, she's just tired of holding a baby that weighs maybe twenty-four pounds. Babies don't know how much they are loved by their mothers. The children love their parents at the same time, but they don't know much about love. You can see the colors of happiness and some darkness—the painfulness the mothers have gone through.

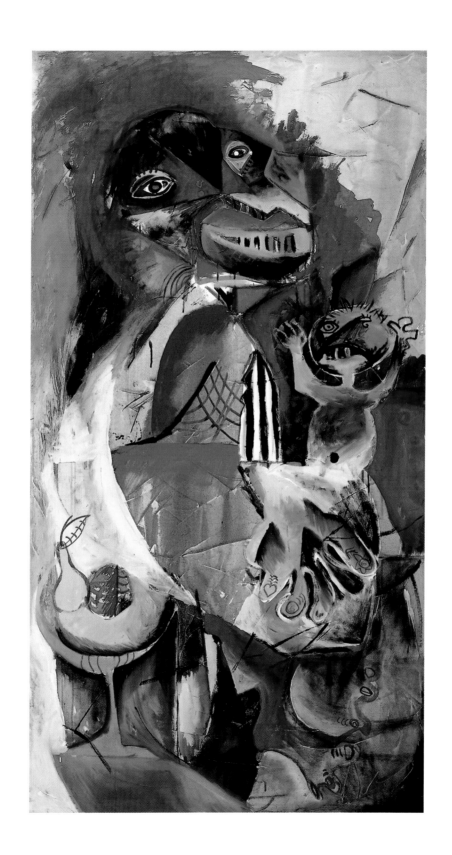

Release the Peace

42" x 68", oil and acrylic on canvas, 1995

The white dove in this painting symbolizes peace. In his beak he is holding a black flower, a white flower, and a yellow flower, and each flower represents a different nation. The three pairs of hands release the peace to the world, to let it fly all over the world and to give peace to everybody. The olive branches are a symbol of peace from the old days—to let everybody know that peace has been loved and supported not only by our generation but by past ones, too. The star is standing there for pride.

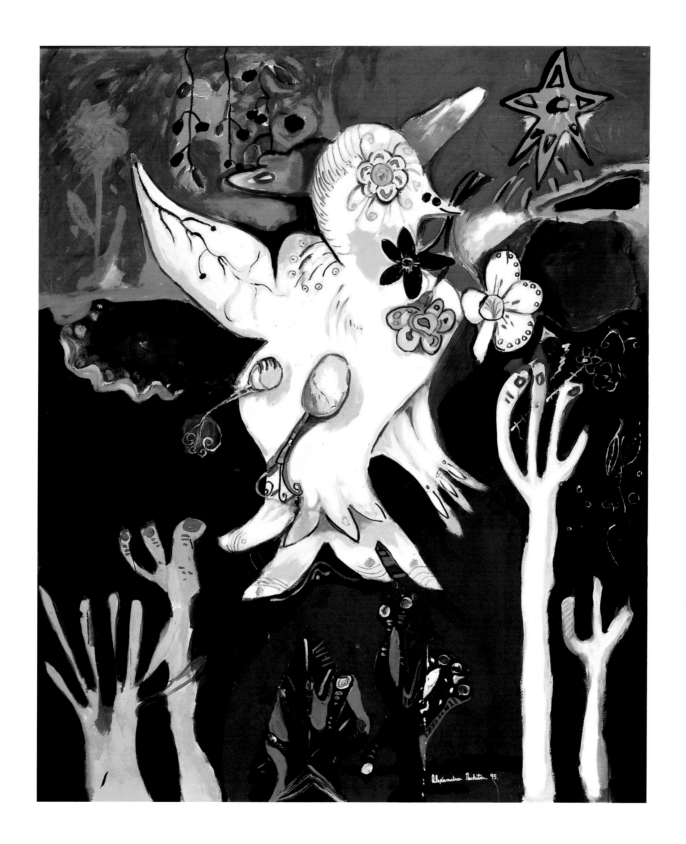

Green Rush

48" x 60", acrylic on canvas, 1995

This painting is about nature and how much people want to preserve it. When there was the Gold Rush, they had gold fever, and now people have Green Rush because they are trying to preserve our nature. Some people don't realize how important this is to all of us. Yet so many are immigrating here from different countries now, and we need to make homes for them, too. This man right here is in a way digging for our nature; he's looking for it. The person on the left is thinking, "Where has it all gone?" *Green Rush* is one of my favorites; I just love the colors.

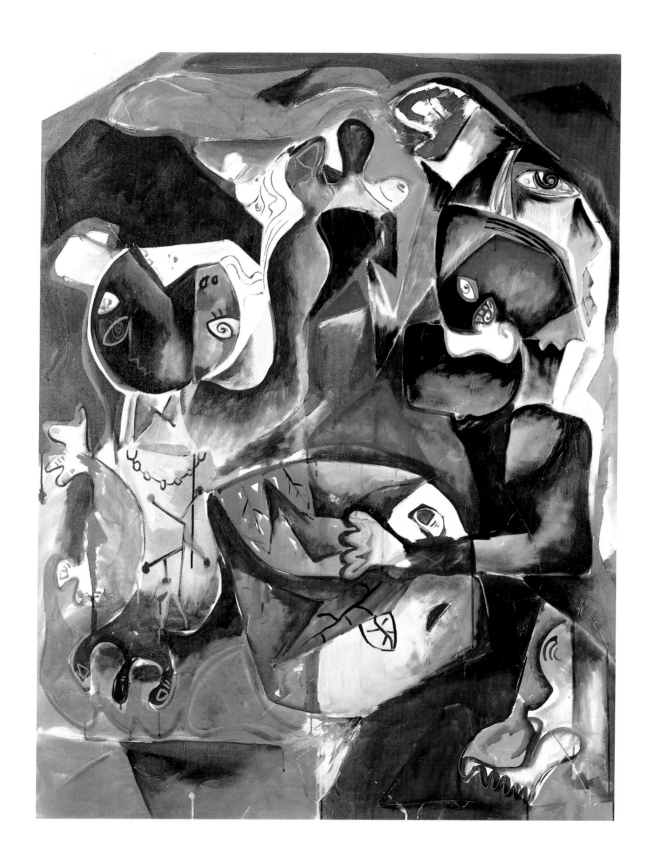

California

36" x 72", oil on canvas, 1995

This lady is the state of California, and she's holding beautiful flowers that symbolize California. The painting is showing how proud I am to be an American. I am grateful that my parents chose to live here. You can see two shades on the face and the two different eyes. I want everybody to know I'll never forget Romania, the country where I was born. But I'm very proud to live here.

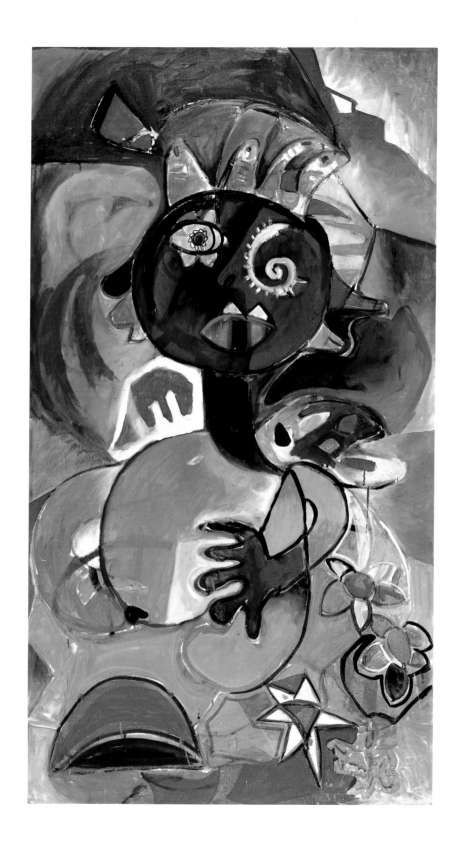

Speaking Same Language

36" x 72", oil on canvas, 1995

On this painting the person is playing an instrument. The harp is part of his body, so it shows his love of music. This white dove is also—how can I say?—part of him. The image above the person is an angel, and there are flowers surrounding him. The language is music, peace, and harmony.

Painting is the best way I can express my feelings, and I am happy others can appreciate that. My feelings are telling me to do this, to put that color on there. All I know is I'm surrounded by angels and by Jesus.

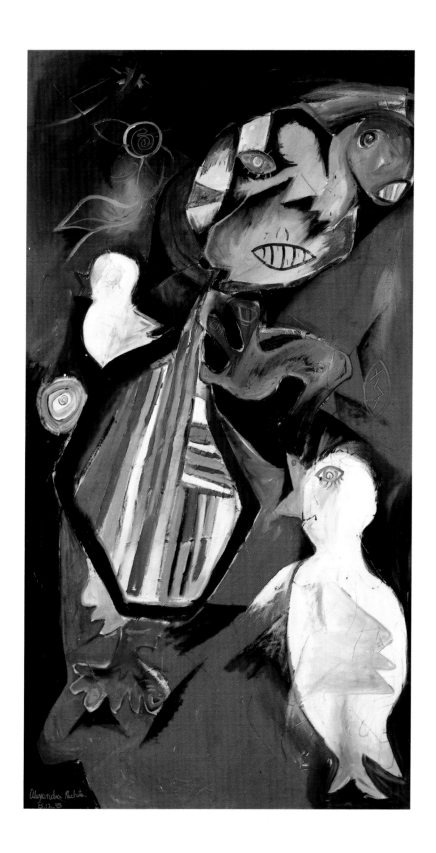

Oklahoma: Terror and Tears

55" x 96", acrylic on canvas, 1995

This painting is about the Oklahoma City bombing. It's based on the famous picture of the fireman with the baby who died in his hands. You can see he's blue because of the sadness. The whole painting is dark, dark, dark. It was such a terror what they went through—all these innocent people died just because of somebody who didn't have a mind, who didn't think of others but thought just of himself. The white dove is hoping someone is going to save the children. The green image is the child the officer is holding. The yellow ones are people falling out of the windows.

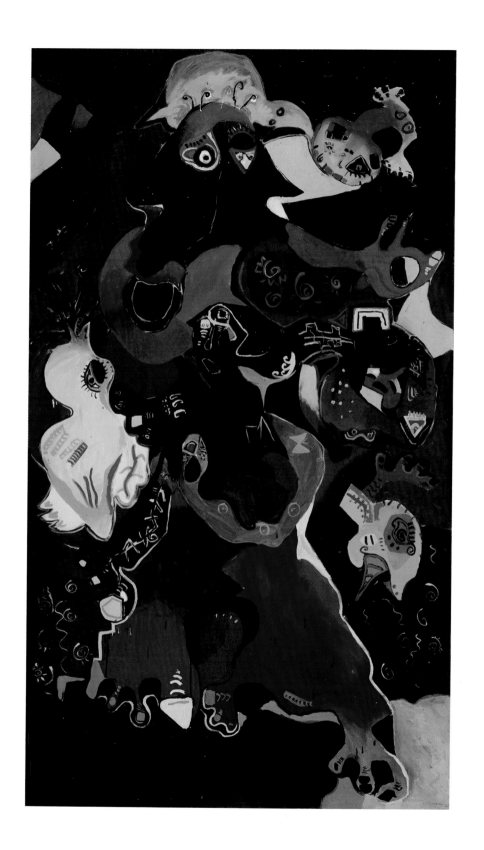

The Ballerina

50" x 72", oil on canvas, 1995

In this painting one part of the ballerina—or gymnast or anyone who succeeds in her dreams—shows that she appreciates all the hard work her teacher makes her do; but the other goes off and humiliates the teacher by telling people that he is making the children work too hard. Mostly she is appreciating how strict her teacher is, because that's the only way she'll learn to be the best at what she's doing. You can see all the movements of the paintbrush, the vibrations through the bright colors, an extra hand and an extra leg. It's a happy painting. I like to dance!

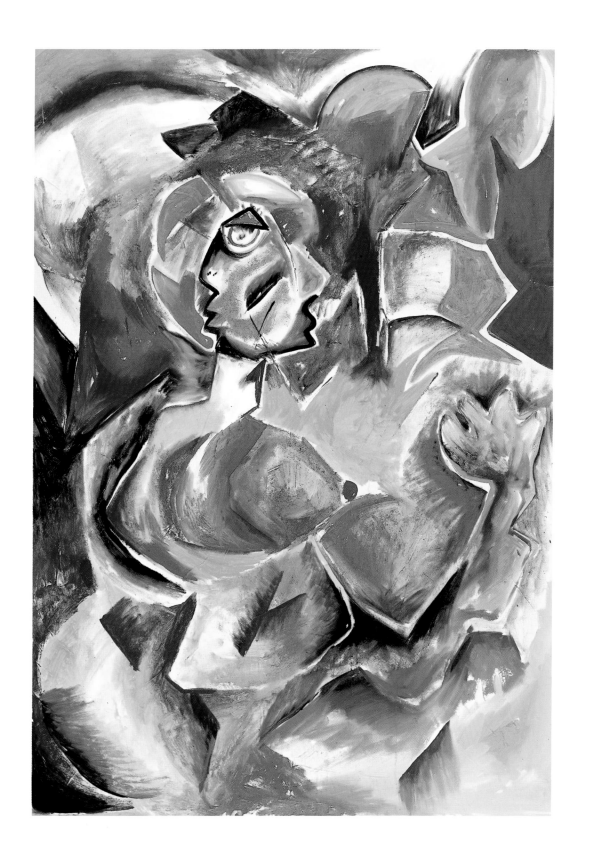

Looking Ahead

36" x 60", acrylic on canvas, 1995

People see the world differently, and some encourage you a lot more than others, and are a lot more supportive than others. This painting says, if some people aren't encouraging you to do what your dream is to do, just look ahead, don't look at them, just imagine what others in the future are going to say. Be encouraged by the ones who are encouraging you. Even a child understands what encouragement and discouragement mean. And you know something? Discouragement somehow finds shortcuts to get to your brain.

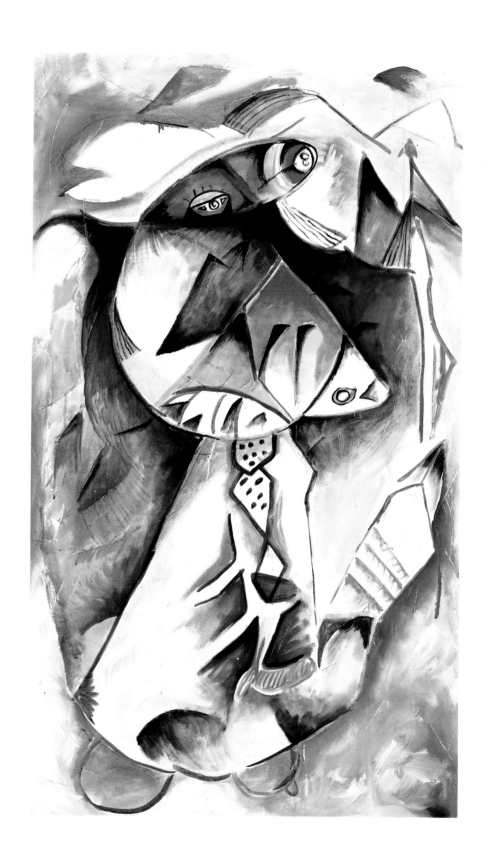

Luceafărul
[LÜ·CHÄ′·FÄ·RÜL′]

60" x 80", oil on canvas, 1995

This painting was inspired by the longest and best-known Romanian poem, "The Evening Star," by Mihai Eminescu. In the poem the girl asks the star always to come and be with her, to guide her way in good times and bad times. You can see all the colors—a lot of bright stuff in the middle and dark, dark on the way out to the edges. You'd have to read the poem to understand my preference for these particular colors. The star—I didn't want it to be too obvious, to look like an exact little kindergarten star, so I just spread it out, spread it out, so it could join with the background. Stars are very dear to me.

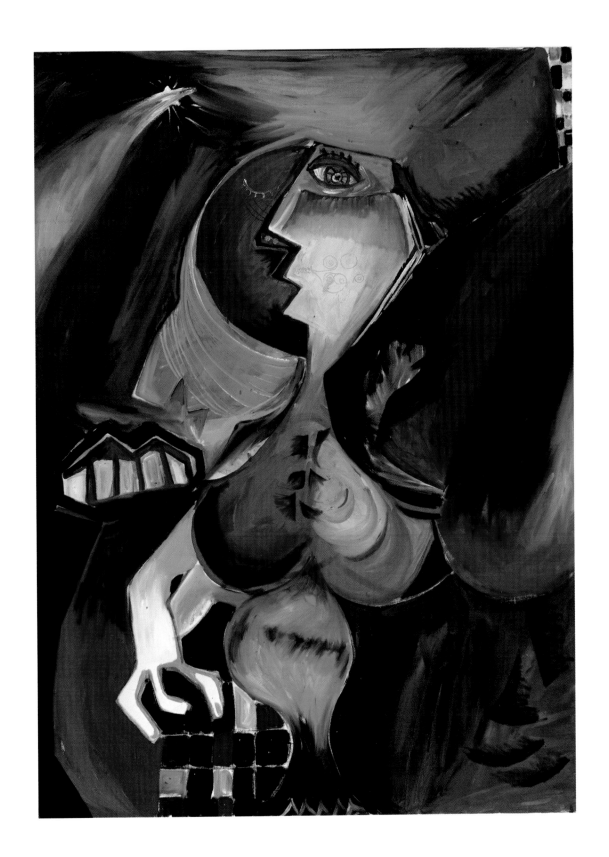

Desert Heat

36" x 60", acrylic on canvas, 1995

When I went to Las Vegas for Art Expo last year, I wasn't used to

that terrible heat. You can see that one side of the face is happy,

another is not too used to the weather, not happy. All the red is

showing the heat, the warm things that happened there.

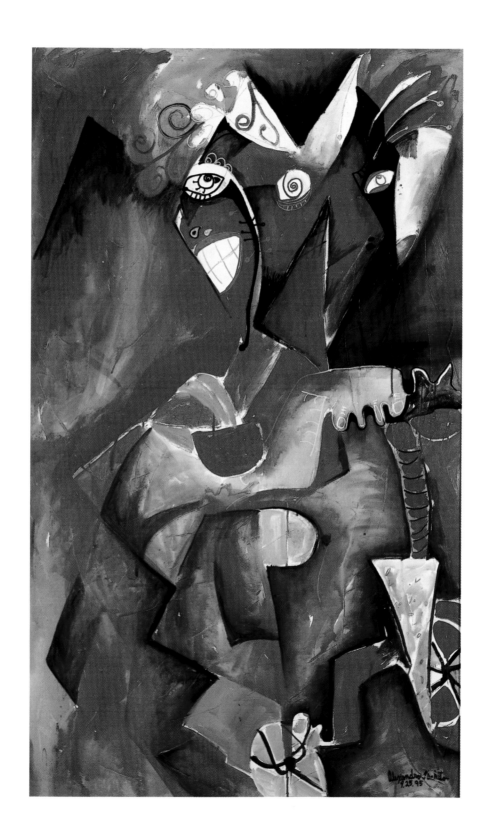

Volcano Symphony

36" x 72", oil on canvas, 1995

This is the profile of a volcano, and it's about how expressive nature is. Not only are we afraid of volcanoes, but some people don't realize how much music they send to us. They can send beautiful music and scary music—you never know. When all that lava falls out plop, plop, plop, it's part of the music. The red image with the musical notes is an instrument bringing the symphony. The body is a home, and it's right off the volcano. All the music is coming out—it's so explosive, a beautiful sight. (Personally, I am very afraid of even hearing about volcanoes, but we have to realize they bring good and bad at the same time.)

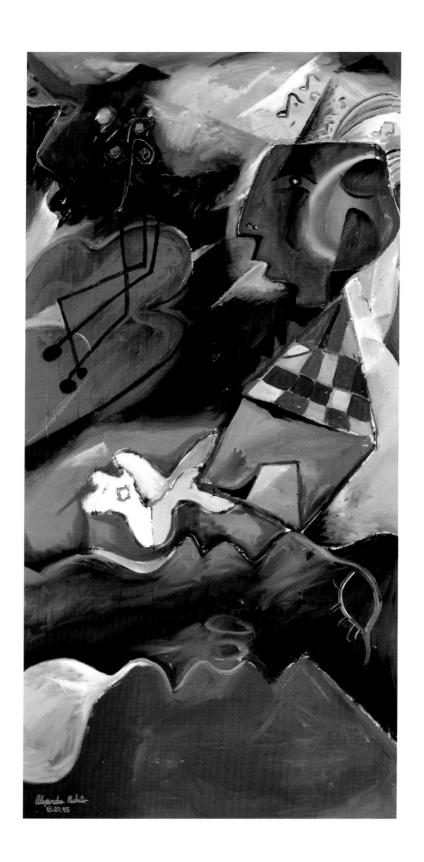

Geometric Look

36" x 60", acrylic on canvas, 1995

I was just playing with the colors and the shapes. The shades and contrasts express a lot. What looks like a lot of white space is a light orange—I used a lot of water and a little drop of orange paint. I was just playing, playing, playing. The textured ridges of paint give my paintings a lot more richness, it makes them a lot more expressive.

What's it about? Well, I don't want to just use a body, a body, a body, even though it's geometric. Combining a musical instrument with a body, for instance, is more interesting; it makes people think, "Why did she do that? What is that—a house, a toy?" I really want them not just to see what the thing is—a vase or a piano—but more.

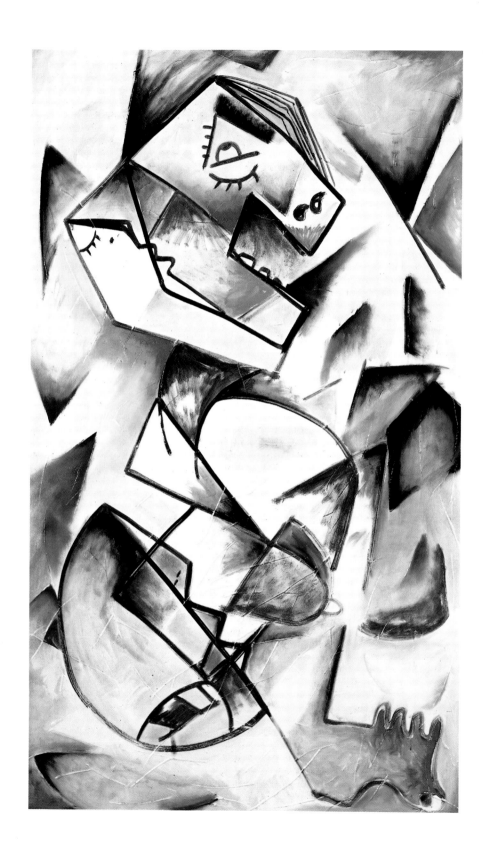

Swimming Lessons

36" x 40", acrylic on canvas, 1995

When I was young, my friends and I would go swimming and most of us didn't know how to swim. Usually the father teaches swimming, so the dads would come and help us do the doggie paddle. All of us would fall back in the water blublublublublub—it was very funny. In the painting the swimming teacher is on top, and the swimmer is trying to float on her back. The teacher's legs are going fast because the child is wobbling all over.

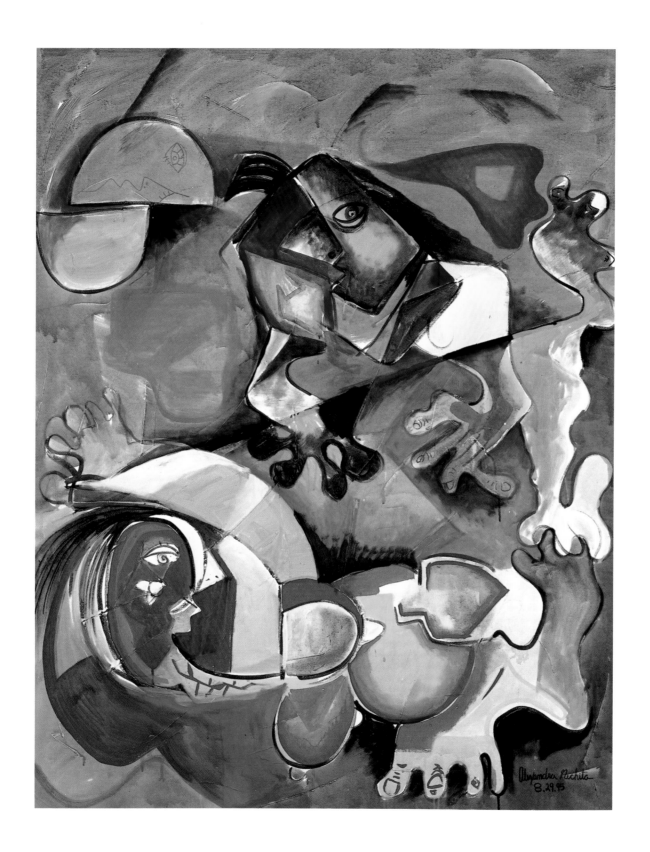

Mandolin Soul and Bleu Cheese

36" x 60", oil on canvas, 1995

You know how they have salad dressing called bleu cheese? I thought that it was really *blue* cheese. I don't like it anymore. Maybe I will in the future. The painting is a combination of tastes for food, music, and nature. The person in the painting is playing the mandolin, and it's part of the person's soul because he's so attached to it. Then I added the bleu cheese, the vase, and the flowers.

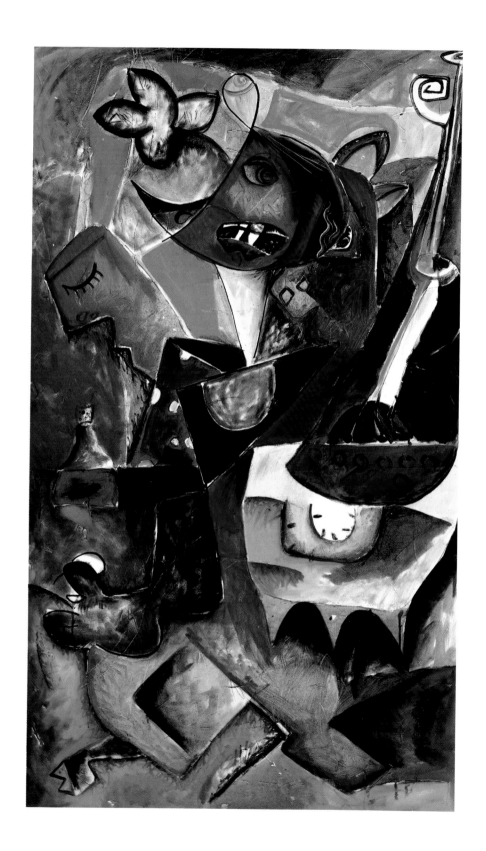

Artist's Universe

36" x 60", oil and acrylic on canvas, 1995

I dedicate this painting to all the artists in the world because they've dedicated their lives to art. This yellow head could be me, since I've been trying to succeed as an artist. These are the paint-brushes, and here are my hands—or any artist's hands. In the painting the artist is in her own world; nobody's telling her how to feel, nobody's forcing her to do anything she doesn't want to do. Sometimes I get so immersed in my paintings I'm just somewhere else. I create my own universe that you get to see little by little through every painting I work at. And every painting I create is part of me going out little by little to all of you. You know, it's not easy to let go.

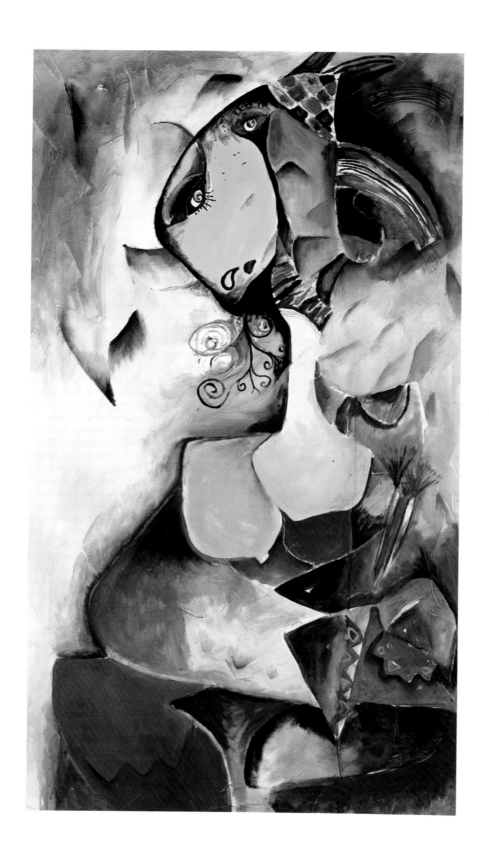

Twin Lives

36" x 60", oil and acrylic on canvas, 1995

This painting is about brothers or sisters without sisters or brothers. That's how I felt without my baby brother—a sister without a brother. The first day he was here, I said, "Now I'm not going to be alone anymore!" You can see they are both sharing sadness, and they are sharing a happy face at the same time. They promised to each other never to be apart.

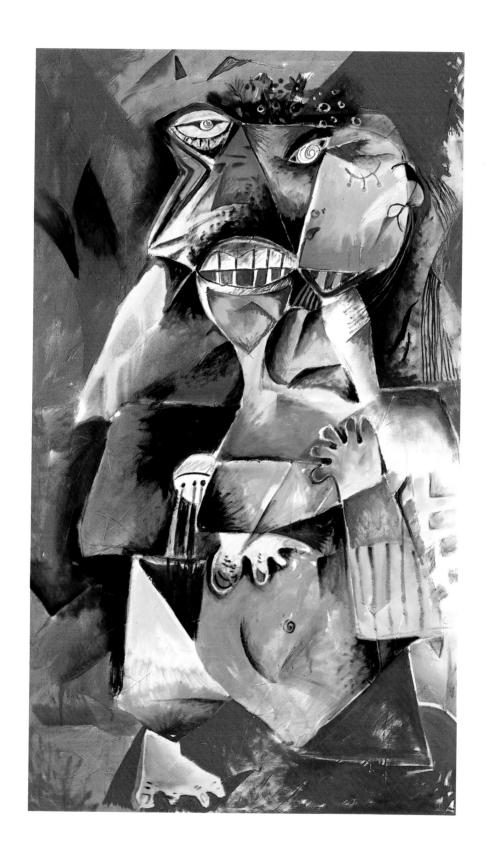

Healing Efforts

36" x 60", oil and acrylic on canvas, 1995

When I was very sick last summer, it was a real effort to cooperate with my body. My mind and my body were doing different things, and my body was taking over my mind. The red is the fever part—I had a fever of 104.9 degrees. The trumpet is bringing a dove because doves heal people. This is the only turtle I've painted—it turned out so beautiful that I loved it. You might wonder how come all of a sudden I came up with the turtle. Turtles move slow, very slow—and this is how my illness moved away from me. I knew it would be a bit hard to figure out this one!

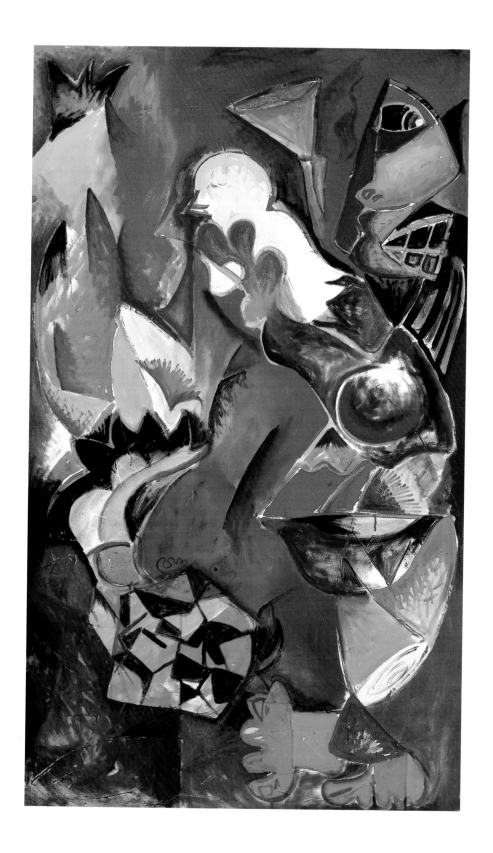

Apple Planet

36" x 60", oil on canvas, 1995

Some people escape to another world because they choose to do something different. So many people are laughing at them that they wish they were on a different planet. I'd like sometimes if there would be an apple planet that I could go to. I love the fruit, for one thing. If I could live in an apple, climb to another apple, go on the clouds…it would be so neat, something very fun. That's my planet; maybe you'd choose a banana planet or a milk planet.

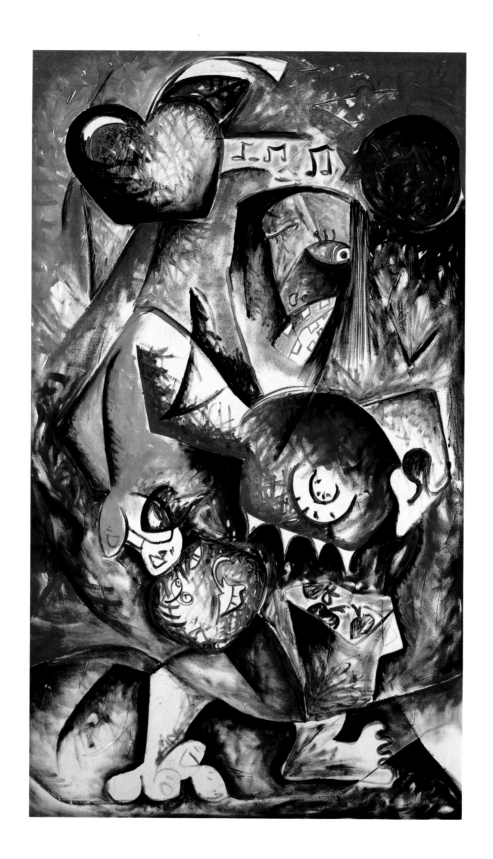

Sky Diving

36" x 60", oil and acrylic on canvas, 1995

This painting is about the courage skydivers have to jump out of a plane. I wish I could do something like that. Seeing people do that—it's so freaky, I'm so scared at the thought of skydiving. In the painting you can see the plane from where they are jumping down, the colors of happiness, and also the frightening, sad part in the dark colors.

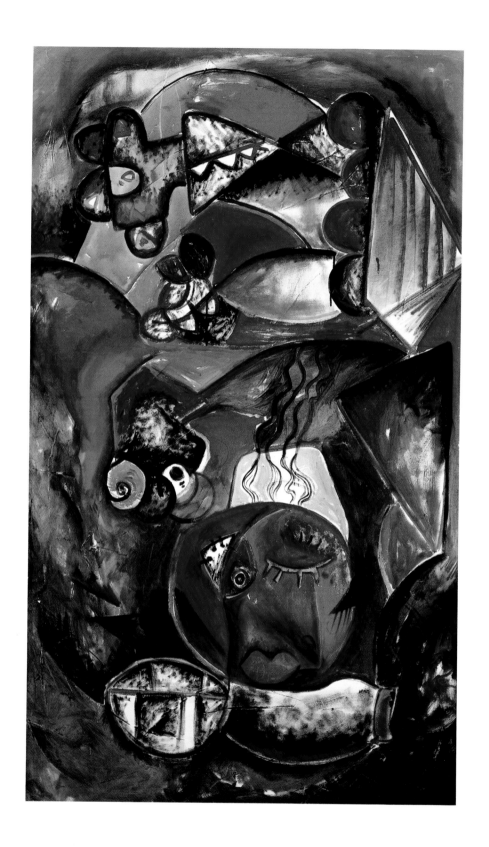

Forgotten Culture

36" x 60", charcoal, acrylic, and oil on canvas, 1995

Some people who emigrate to other countries forget about their culture. They don't necessarily forget about where they were born—but they forget by not listening to the music of their country, eating the food, or celebrating different holidays. But I know that will never happen to me. We eat the same food as we did in Romania; we listen to the music and celebrate the holidays from my home country. I'll never forget Romania and neither will my baby brother, even though he wasn't born there. I put different things in the painting—an instrument, some food, an elegant tablecloth, the faces of different people.

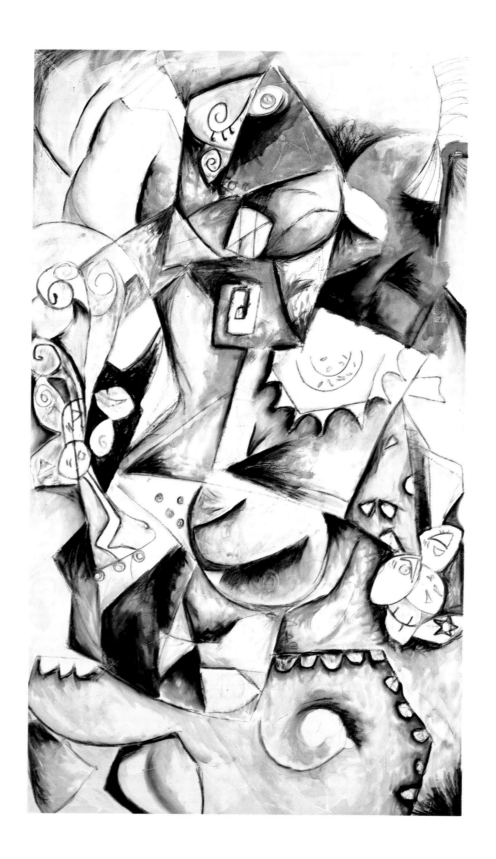

Some people hide their fears by lying and not telling the truth.

They think the only way they can get friends is by lying, but you

can't hide the truth if you want to make friends and meet new peo-

ple. You always have to be honest. I have known people who don't

tell the truth but I try to keep friends who are honest. In the paint-

ing you can see the person is covering her face with her hand. The

expression on your face shows what you're thinking, whether you

are lying or telling the truth. The only way to succeed in life is just

to tell the truth.

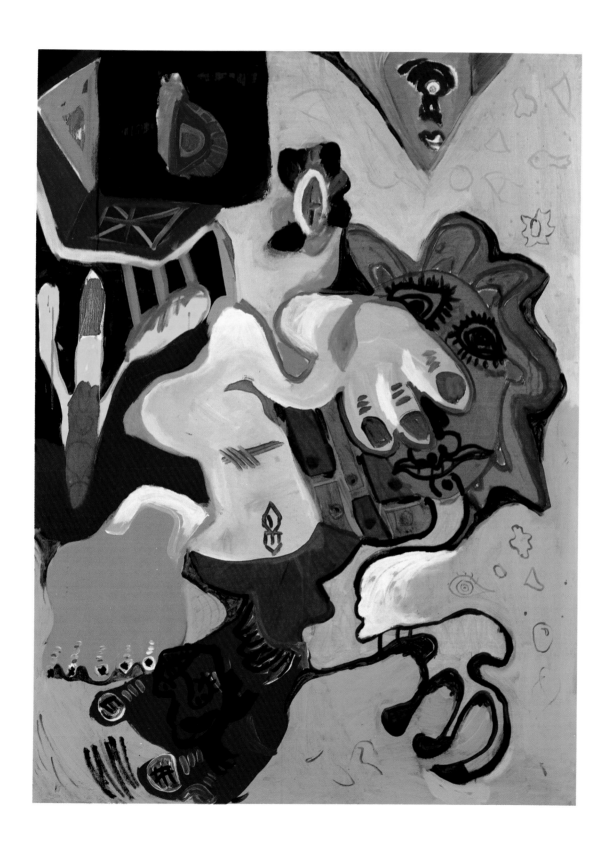

Pistachio Flowers

36" x 60", oil on canvas, 1995

When Uncle Gabi, my mom's brother, came to America several years ago, I remember that he loved pistachios so much that he would eat them for breakfast and lunch and dinner. I remember seeing all those empty pistachio bags and the shells in the trash cans. Because he loved pistachios so much and they grow on trees, I decided to paint him as a pistachio flower. He is like a blossom, just like the pistachios. He could be salty, too.

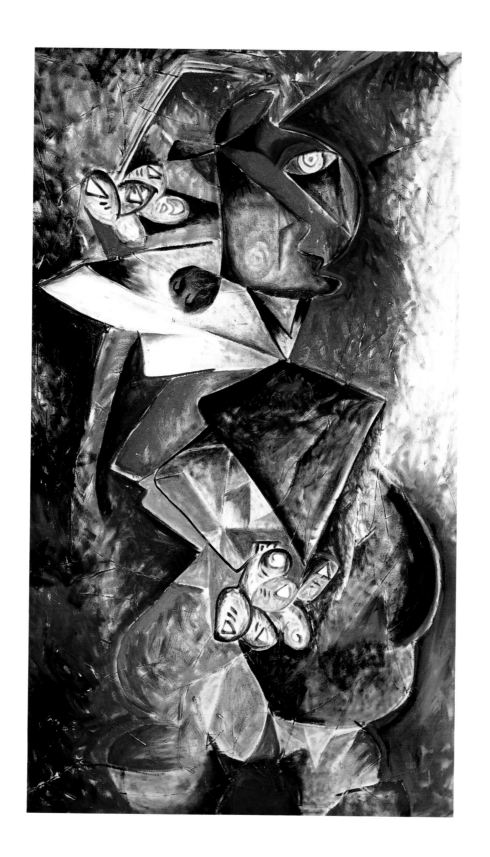

Moody Guitarist

36" x 72", acrylic on canvas, 1995

I chose the guitar to paint about the bad moods people get in when something they are working on doesn't turn out the right way. When an artist paints a line by mistake, the artist thinks that one line destroys the whole painting. But that line could hold the meaning of the painting. I might think it is a mistake, but others might think it's a masterpiece. With music it's different, though. I wonder, is it tougher? There are three people in this painting on one head, and they are holding the guitar together. It shows how people have to work together in an orchestra. If a musician plays one bad note, it ruins the whole piece, and all the money the people paid is wasted (not to talk about their feelings and expectations).

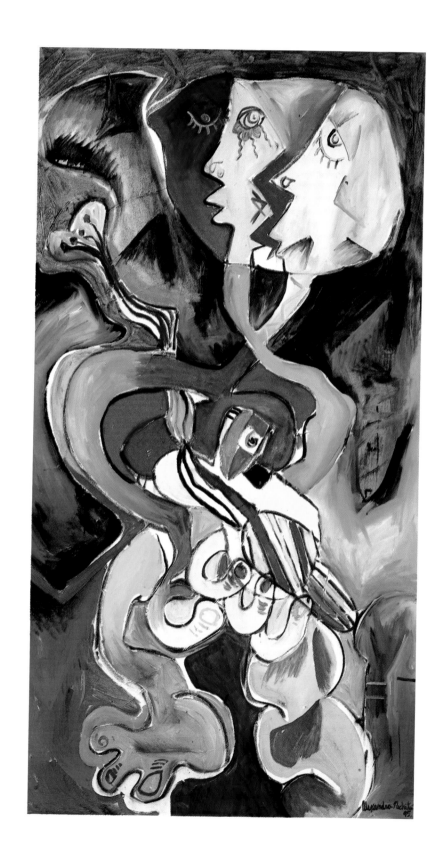

Old and Happy Friends

36" x 60", oil and acrylic on canvas, 1995

This painting is about friends who remain friends forever, regardless of time and distance. You have to take care of a friendship even if one person moves away. You have to keep the friendship alive by keeping in contact with each other. Through good and bad times you have to be there for each other—true friends will not betray the other one. Some don't keep their friendships alive—they lie to each other or aren't loyal. Old and happy friends will never disappoint or betray the other one.

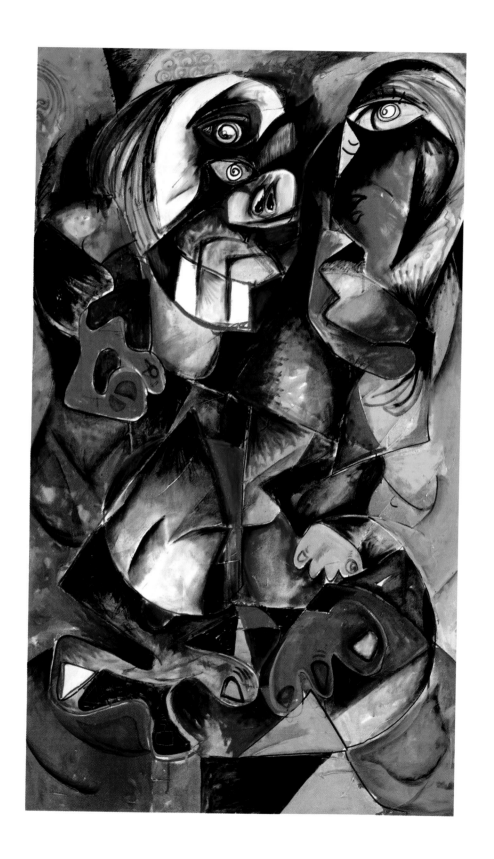

Spring Love

36" x 60", oil on canvas, 1995

In spring all the flowers blossom, and it's that time of year when you get to smell the flowers—the tulips and dandelions, and all those beautiful flowers. You can see there's a lot of love in this painting—red, pink, purple, and gold—because when flowers are blooming it's like love. We don't want to see the flowers closed up in their buds; we want to see them open, joining with the world. There's a little child on the left-hand side of the painting; it represents the love from our moms and dads and grandparents.

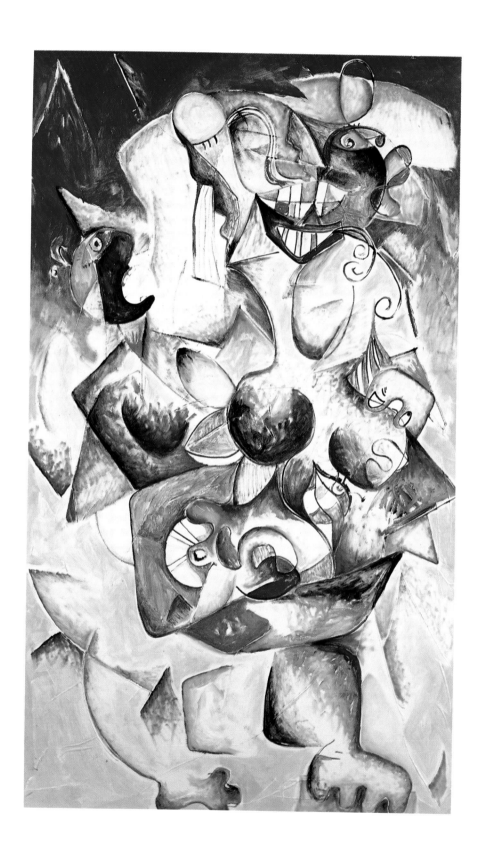